The Critics of
Abstract Expressionism

Studies in the Fine Arts: Criticism, No. 2

Donald B. Kuspit

Chairman, Department of Art
State University of New York at Stony Brook

Other Titles in This Series

The Critics of
Abstract Expressionism

by
Stephen C. Foster

RESEARCH PRESS

Text first published as a
typescript facsimile in 1973

Produced and distributed by
UMI Research Press
an imprint of
University Microfilms International
Ann Arbor, Michigan 48106

Library of Congress Cataloging in Publication Data

Foster, Stephen C
The critics of abstract expressionism.

(Studies in fine arts : Criticism ; no. 2)
Bibliography: p.
Includes index
1. Abstract expressionism—United States. 2. Art
criticism—United States. I. Title. II. Series.

N6512.5.A25F67 750'.1'18 80-17239
ISBN 0-8357-1088-2

Contents

List of Plates

Foreword

The role of the art critic is paradoxical. He makes the first, and presumably freshest, response to the work of art, grasps it when it is still new and strange, and gives us a preliminary hold on its meaning. Yet his response is not comprehensive, for it is inexperienced: the work has not yet had a history, a context of response to give its "text" density. When the critic encounters it as a contemporary product, it lacks historical "bearing." Indeed, part of the critic's task is to win it a hearing at the court of history. This is why, as Baudelaire says, the critic is often a "passionate, partisan observer" of the work, rather than a detached judge of its value. As its contemporary, he plays the role of advocate, knowing the case only from the viewpoint of the work itself. For the sensitive critic the work will always remain a surprise, and he will always be its enthusiast. He will leave it to the future historian to engage in that dissection of art which presupposes a settled opinion of its significance.

Yet—and this is the paradox—the temporary opinion of the critic often becomes the characteristic one. The critic's response is, if not the model, then the condition for all future interpretation. His attention is the work's ticket into history.

A sign of the critic's power, in modern times, is his *naming* of new art. Louis Vauxcelles' labels "Fauvism" and "Cubism," for instance, have had an enormous influence on the understanding of these styles. Through such names art assumes an identity for future generations. And an understanding which begins as no more than a "semiotic enclave," to use Umberto Eco's term, becomes a whole language of discourse, creating an entire climate of opinion. Clearly, the responsibility is awesome. Clement Greenberg once wrote that the best moment to approach a work of art critically was after the novelty had worn off but before it became history. Yet it is at just that moment that the work is most unsettled and vulnerable, when the critic's swift "decision," in the form of an impromptu name, can seal its destiny forever. In so seemingly trivial an instance as naming we see criticism's enormous power of determination.

Criticism, then, as Oscar Wilde wrote in "The Critic as Artist," is vital to art. Criticism grasps and preserves, cultivates and exalts. The history of art criticism is the history of different generations' responses to the art. No doubt

the interests of the generation determine what is interesting about the art. As Reinhild Janzen tells us in her study of Altdorfer criticism, the assumption of *Rezeptionsgeschichte*—the history of critical response to an art—is that "a work of art is a piece of dead matter until it is drawn into a dialectic, dynamic relationship with an observer," and the interests of the observer obviously influence the nature of the relationship. The history of art criticism is both the record of such relationships and the demonstration of their significance to the work of art. This insight underlies the Janzen study as well as the other volumes in this series.

At stake in the encounter between art and its observer is ideology or, in H. R. Jauss' words, the "recipient's ... horizon of expectation." That ideology both conditions the recipient's response to the work of art and is itself affected by the encounter.

At the same time, as Janzen says, the recipient's horizon of expectation leads to the differentiation between "primary and secondary types of reception. The first is the original experience or encounter with a work of art." The second is influenced by "knowledge of preceding, traditional interpretations." In Janzen's study, Freidrich Schlegel's essay on Altdorfer's *Battle of Alexander* is an example of primary reception and Oskar Kokoschka's later interpretation of the same painting illustrates secondary reception. Clearly, from the viewpoint of *Rezeptionsgeschichte,* there are no absolute criticisms of art, for even the primary reception is determined by the interests of the critic, and thus is dialectical. Indeed, as Janzen implies in her endorsement of Herder's concept of criticism, the recognition of the dialectical character of criticism that *Rezeptionsgeschichte* forces upon us is an antidote to "aesthetic historicism's static view of history," i.e., its concept of the aesthetic finality of the work of art.

This series of titles selected from dissertation literature exemplifies *Rezeptionsgeschichte* in a variety of ways. First, it shows us the history of the reception of artists whom we have come to regard as "major," in particular Altdorfer (in the Janzen volume) and Van Gogh (in Zemel's study). The authors discuss both how these artists moved from minor to major status and the meaning of the move for the culture in which it was made.

Second, the series offers us the history of individual critics' reception of a variety of art. We trace the development of a characteristic view of art in Baudelaire, Ruskin, and Pater (in the Johnson work), in Champfleury (Flanary), and in Claudel (Gelber). Sometimes, as in the case of Champfleury and Claudel, we are dealing with figures whose primary identity does not seem connected with the visual arts. At other times, as in the cases of Baudelaire, Ruskin, and Pater, even when the figure is associated with the visual arts, the ideology is grounded in larger cultural issues as well as other, usually literary, arts. The perspective of such a mind often leads to unexpected insights and lends fresh significance to the work of art.

Third, the series addresses the critical response to whole movements of art, in particular Cubism (in the Gamwell treatise) and Abstract Expressionism (Foster). We learn how an art that seemed aberrant came to seem central and how critical response created a unified outlook on a highly differentiated group of artists.

Fourth, we have portraits of figures—Félix Fénéon by Halperin and Roger Fry by Falkenheim—who are more or less exclusively art critics. As professionals their horizons of expectation developed in close encounters with art. And their outlooks are also shown to involve larger cultural orientations—the ideology that makes their responses to art dramatic, part of a larger dialectic, dynamic relationship with their culture.

Finally, Olson's treatise examines the development of journalistic criticism in New York. We see *Rezeptionsgeschichte* as it enters a new, democratic, populist phase. Journalistic critics spearhead the advance of culture for the masses in which the encounter with art is there for the asking by anyone.

These five genres of *Rezeptionsgeschichte* demonstrate the richness and complexity of art criticism as an intellectual and cultural enterprise. They also make clear that there is no such thing as neutral, ideology-free criticism. Indeed, the very meaning of criticism is to put information to a larger use, to subject it to an *Aufhebung* or mediation which makes it truly telling—truly revelatory of the art. Art criticism, as it is examined in these volumes, is neither description nor evaluation of art. It is a means of entry, through art, into a study of the complex intentions that structure the life-world, and a demonstration of art's structural role in the life-world that produces it.

In concluding, let us note some particulars of the volumes in this series, especially the ways in which they tie in with broader cultural issues. Janzen makes clear that Altdorfer's reputation hangs on the familiar North/South—Northern Romantic/Southern Classical—conflict. Altdorfer's slow acceptance corresponds to the reluctant acceptance of Northern irrationality or abnormality and Southern (Italianate) rationality and normativeness. In her study of Van Gogh Zemel shows that at issue in the reception of Van Gogh's art was the artist's temperament or emotionality, as the foundation of his creativity. Van Gogh came to be accepted when it was recognized that emotions were a major component of creativity. Van Gogh's art became the proof of this assumption.

Johnson shows us that the art criticism of Baudelaire, Ruskin, and Pater demonstrates the growth of bourgeois individualism. The "poetic" individuality the critic can achieve through the art becomes emblematic of bourgeois self-possession and integrity in the eyes of the world. Their art criticism is also caught up in the shift from the concept of art as a (romantic) depiction of nature to the idea of art for art's sake. Art for art's sake is another means whereby individuality is achieved and refined.

In her work on Claudel, Gelber offers us a new perspective: modern art

seen in a religious context. Claudel is haunted by the possibility of a modern religious, specifically Christian, art. Gelber shows how one well-formed ideology, even if based more on non-art than art encounters, can lead to a powerful analysis of art. Flanary makes a similar point in his study of Champfleury, although here the ideology is secular rather than sacred. Champfleury's sense of the importance of realism and Claudel's sense of the importance of Christianity as comprehensive *Weltanschauungs* shape their perspectives on art.

In Gamwell's volume on Cubist criticism and Foster's on Abstract Expressionist criticism we see the way in which complexity of meaning can interfere with an understanding of art. In these studies we have a sense of how much an art can deliver, and how uncertain we finally are about what is delivered. Yet, we sense that the art is aesthetically important because it has become a stylistic idiom for many.

Halperin's work on Fénéon offers us a study of a critic's language. In Falkenheim's book we learn the historical background of Roger Fry's formalism, which became a major ideology as well as an empirical mode of analysis of 20th-century art. Olson acquaints us with critics who claim to represent the masses in their encounter with art—popularizers of criticism as well as of art. All three studies show us criticism in a practical as well as theoretical light. Criticism can be a short, sharp look as well as a considered opinion, a way of dealing with a newly given object as well as with a standing problem.

These volumes demonstrate the versatility and subtlety of art criticism. Whether we accept Robert Goldwater's notion that criticism is a "provisional perspective" on art and so implicitly journalistic, or Pater's notion that it is a means to profound spiritual experience and self-discovery, or Claudel's view that criticism is the study of art in the light of a dominant *Weltanschauung,* art criticism displays a unique range of methods for the investigation of art.

<div align="right">

Donald B. Kuspit
Series Editor

</div>

Preface

Historians of Abstract Expressionism have generally attempted to discern through its critics the content or meaning of the particular works of art they address. The historian's position here is exactly equivalent to the public's, however, and curiously unhistorical as regards the critic. The question asked is whether the critic is right—whether his criticism works—and only rarely, whether his criticism has historical significance beyond this. My aim in this book is to examine mid-century American criticism, not only as a means for understanding pictures, but as an activity which itself provides insights into certain major artistic phenomena of the times.

One of the primary tasks of such a work is to describe the critical literature in some detail and to indicate its historical sources. Since the literature on the new art is not large in the early stages, recognizing the profiles of the major competing trends is relatively unproblematic. Where exactly this early stage falls would seem to be best indicated by various critics' expressions of a need for new strategies and categories. Such an expression occurs on several occasions around 1945. Sidney Janis, in his introduction to Mark Rothko's show at the Art of This Century Gallery, recognized the ill fit of existing categories.[1] The same year Robert Coates, speaking of William Baziotes and Jackson Pollock, observed the following: "I feel that some new name will have to be coined for it, but at the moment I can't think of any."[2] Howard Putzel, who had begun his career in America as Peggy Guggenheim's assistant, organized a show called "A Problem for Critics" which expressly invited the critics to try their hands at naming the new development.[3] Shifts in ideological sources, like the interest in existentialism among artists and critics around 1946, also provide some help in locating the beginning.[4]

Most sources of abstract-expressionist criticism may be found in previous criticism, although aesthetics, ethics, political philosophy, and other intellectual enterprises seem to be important for the initial formulation and early stages of the new criticism. Instances of such sources for the criticism of the forties would include John Dewey's aesthetics, existentialism, and, particularly for the artists, Jungian psychology. By contrast, most criticism of the fifties and sixties issued from, or in reaction to, earlier criticism.

Besides the "belief" or "idea" generating sources described above, the antecedent conditions of criticism such as the work of art, aspects of the

political or social scene, and the relationship of the artist and critic also require some explanation. These and like phenomena provide the context through which meaning in criticism was acquired and might be designated the "culture" of criticism.

Whom we are to identify as critics also deserves some mention. The traditional criteria for distinguishing critics would seem to suffice here were it not for the fact that they and the artists frequently quoted each other, addressed the same questions in print, shared the same vocabulary, had equal access to the press, and have even formulated their statements in the actual presence of one another. There is, consequently, a considerable literature by the artists themselves. In view of this, their omission would seem arbitrary. Nevertheless, certain things did distinguish their roles, even as authors, and partially conditioned what each has said, a problem I develop further in the course of the book.

The following text is loosely divided into three main parts. Chapters 2 through 5 treat the transitional literature of the early forties and the initial statements by avant-garde critics, notably Greenberg and Rosenberg, later the same decade. The second part, composed of Chapters 7 through 9, discusses the proliferation of more traditionally based criticism in the fifties and the general dissatisfaction with earlier avant-garde extremism. Involved with all this were increasing tendencies for critics to reevaluate their own production more critically and the emergence of a more historically inclined criticism. In the final part, the quantitative lapse in abstract-expressionist criticism and its retrospective character in the sixties are discussed. Also of interest in the sixties is the explicitness of the historical approach to both earlier criticism and painting only implicitly contained in the writing of the fifties.

Of the three decades covered in this book, the forties have received the fullest development. This emphasis on the early stages has developed for several reasons. First, the critics that emerged at this time as the movement's major spokesmen retained their leadership throughout the fifties, and to a large extent, the sixties. Secondly, the main tenets of these critics' arguments did not change significantly after the late forties. Finally, the debt of criticism to various non-artistic aspects of culture which gave some, although not all, criticism its particular flavor appeared almost entirely in the forties. From the early fifties on, criticism increasingly depended on mining its own recent past for new directions.

The Political Background

Although Abstract Expressionism is commonly billed as America's first signifi-
cant contribution to international currents of art, it is a well-known fact that
earlier in the century the United States had already mounted a full-fledged
modern movement, manifested in a variety of critics and all the trappings of
the avant-garde. The 1913 Armory show was accompanied by its critical enthusi-
asts Henry McBride, Charles Caffin and James Huneker, all of the New York
press. Just as important as these critics were the lawyer-collectors, Arthur J.
Eddy, author of the first American account of Cubism in 1914 *(The Cubists
and Post-Impressionism),* and John Quinn. Finally there was William Huntington
Wright, brother of Stanton McDonald Wright, who founded the movement
known as Synchromism, who became that movement's leading spokesman.

Although it is highly questionable whether or not these men influenced
critics in the forties and fifties, it is worth noting the extent of their "modern-
ism" at this early date. Many claims made for art by these critics in the teens
were recast for art around mid-century. Quinn is described as a man who was
"intensely interested in culture or, perhaps more accurately, the creators of
culture. . . . He supported the creative intention rather than its material result."[1]
Forming a polarity to this is Wright's criticism, in which art is seen to "pro-
gress"—to fund knowledge much the same as science. The content of Wright's
criticism and his formulation of a history of art from the point of view of a
single movement both find their later analogue in Clement Greenberg's criticism.
Quinn's emphasis on the creative intention and his comparative indifference
to the work of art reappear in the criticism of Harold Rosenberg. Equally
modern, and perhaps more directly influential on mid-century critics, were the
writers for *Camera Work* and other little magazines connected with the Stieglitz
and Walter Arensberg circles. Benjamin de Casseres and Marius du Zayas, the
best known and most frequently quoted among these, will be mentioned further
in connection with later critics.

What is better remembered than the successes of early American modern-
ism, however, is the fact of its failure. Throughout the subsequent period of the
late twenties and early thirties, which has become, for most writers, a sort of
American Dark Ages, modernism, always viewed as rather unAmerican, was
reviled with enthusiasm by such critics of American regionalism as Thomas
Craven. According to Jackson Pollock, later one of the leaders of Abstract

Expressionism, "they put the screws in with a vengeance. . . . You were only trying to find how you needed to paint and you were un-American."[2] In 1936 Craven, in an atmosphere of intense political partisanship, had the following to say:

> The triumphant return of American Art to the consideration of the engaging enterprises of our national life has aroused the indignation of various disgruntled factions. The most vociferous outbursts have issued from the sore throats of the cosmopolitan painters of New York, but the people of America are no longer heedful of the wants of dying modernists. Nor are they heedful of the tirades of that other New York faction, the amateur communists and painters of Russian propaganda.[3]

As for the "professors":

> They profess to love America and all her earnest, aspiring artists, but actually they love only the sweet smells of the departed dead. They seem to think that it is a sin to speak of nationalism, a sign of narrowness, a token of the clodhopper, they counsel us to be broadminded and liberal and tolerant of the superior cultures of Europe. A curse on their tolerance! the whole trouble with America, in aesthetic matters, is her tolerance. She has been, until recently, so gullibly tolerant of imported cultural fetishes that she has remained in colonial bondage to moldering European abstraction.[4]

Already under way in the twenties, American-scene painting was really nothing new and represented a less significant influence on painters and critics of the thirties than the activity of the Communist party. Although an official Marxist organ appeared quite early in the United States (*Masses*, 1911-17), it was only under the impetus of the economic collapse of 1929 that responsible people began to think that capitalism might really be endangered. Speaking through such publications as the *Liberator*, which was the successor to *Masses* and which had adopted a party line in 1922, and the *New Masses* (1926-48), American artists inclined towards socialism or communism evolved an aesthetic. Although ideologically opposed to regionalism, it nevertheless shared its distrust of an elite modernism and aimed to communicate with a mass audience. In both cases, the stress was on subject matter and illustrational techniques.

Communism, or indeed any world movement, has always held special appeal for the embattled minority which requires some vehicle for giving its "sacrifice" some point. American modernists in the thirties were both embattled and a minority. Seeking to establish themselves in a society as professionals, the artists of the Depression turned to one of two sources, or both; the government-sponsored art projects or communism. The popularity of *Partisan Review*, the publication of the New York branch of the John Reed Club (founded 1929), from its inception in 1934, indicated the strength of communism among American liberals.

The appeal of communism for artists and writers was made easier by the fact that the party was dominated in the thirties by the idea of the Popular Front. The party was strong in these years but "the fact that at this time the party line was stressing the importance of opposing facism by means of a Popular Front with non-Marxian parties meant that any specifically Marxian art and art theory was deemphasized."[5] From 1938 to 1939 communism had even tried to extend its membership to non-proletarians. Even so, there were identifiably communist positions taken in art. One of these was

> the reassuring dogma that an appetite for art is inherent in human nature. On this premise, it was logical for the artist to feel that he was in the company of a cultural vanguard engaged in bringing about the aesthetic self-fulfillment of the masses.[6]

Experimental art was rejected as a

> symptom of the collapse of the middle class. . . . Social radicalism now asserted the death of a radical art and bade the artist exchange his investigative and experimental function for a firm role in a political movement of mass education and mass action.[7]

It has been a source of wonderment to many later writers that anyone could have really believed in this program; but, believe they did. Stuart Davis, painter and editor of "Art Front," publication of the Artists Union,

> allowed his friendship with Arshile Gorky [whose painting later helped clear the way for Abstract Expressionism] to lapse because Gorky, despite the political situation "still wanted to play" as Davis put it; that is to devote himself to the problems of painting.[8]

Rosenberg reports that Gorky himself, looking for "a clue to art's next move," attempted to find a "Marxist" approach to painting.[9] Besides the artists, such influential writers as Meyer Schapiro and André Malraux lent their authority. Schapiro, although never relinquishing his historical detachment, nevertheless made certain sympathies clear.

> There are artists and writers for whom the apparent anarchy of modern culture as an individual affair in which each person seeks his own pleasure—is historically progressive, since it makes possible for the first time the conception of the human individual with his own needs and goals. But, it is a conception restricted to small groups who are able to achieve such freedom only because of the oppression and misery of the masses. . . . Further, this freedom of a few individuals is identified largely with consumption and enjoyment; it detaches man from nature, history and society, and although in doing so, it discovers new qualities and possibilities of feeling and imagination, unknown to older culture, it cannot realize those possibilities of individual development which depend on common production tasks, on responsibilities, on intelligence and cooperation in dealing with the urgent social

issues of the moment . . . An individual art in a society where human beings do not feel themselves to be most individual when they are inert, dreaming, passive, tormented or uncontrolled would be very different from modern art.[10]

What distinguishes Schapiro's writing is the feeling one gets that it was written from a broader base than a party platform. Schapiro, himself, is careful to point this out.

> When we speak in this paper of the social bases of art we do not mean to reduce art to economics or sociology or politics. Art has its own conditions which distinguish it from other activities.[11]

His essential endorsement of abstract art and, implicitly, modernism, is clear in 1937 when he observes that "abstract art is [not] dead, as its philistine enemies have been announcing for over twenty years. . . ."[12]

Although there can be little doubt these leftist positions were taken with conviction on a certain level, they did not entirely dominate the literature. In addition to Schapiro there was the formalist Clive Bell, who made the following statement in 1937.

> Art and Religion are not professions; they are not occupations for which men can be paid. The artist and the saint do what they have to do not to make a living, but in obedience to some mysterious necessity. They do not produce to live—they live to produce.[13]

> As for the rulers, it seems to me they can do four things and four only, in the interest of art. To anyone who believes that he is a pure artist they can give leisure, freedom, and a bare subsistence dole, they can refrain from attempting to select pure artists. They can refrain from establishing art departments. An art department means bureaucratic art, and bureaucratic art means death. Finally, to the artist's public— to everybody, that is—they can give an education in seeing. I cannot say I think it likely they will do any of these things.[14]

Two years earlier, Duncan Phillips had anticipated Schapiro's stress on the collective values required of the situation of the thirties, but rejected the claim that aesthetic values could be *evolved* collectively, even in a collectively minded environment.[15]

Just how comfortable artists and critics felt with their situation in the thirties is hard to determine, but certain evidence suggests there was a persistent dissatisfaction over certain things. Artist Peter Busa, for example, expressed concern over his work for the Federal Arts Project.

> What we did on the Project was colored by our having to do commissioned work. Even when paintings were not actually commissioned, artists felt the presence of a commissioning power. Art that "communicated" with the artist's audience or its representatives was encouraged at the expense of intuition and temperament.[16]

Even critic Harold Rosenberg, although a confirmed Communist in the mid-thirties, believes in retrospect, that everyone was inclined to weight his political commitments in the thirties too seriously. Further he believes the scholar in the sixties and seventies has made the same mistake.

> Actually the [Artists'] Congress was only playing at being a professional organization, just as the union of artists on New Deal projects was only playing at being a professional association or a trade union.[17]

Elsewhere, he has described the same ambivalence of artists' and critics' feelings in the thirties.

> The decade of the Depression and totalitarianism that ended in World War II, did not doubt that art was inspired by history. But which history? The history of art, following its own logic, for example that which led from Cézanne through Cubism to Mondrian? Or the history of society which declared art to be a 'reflection' of national or class struggles, of popular myth, or an aristocratic or religious tradition.[18]

Communist influence among artists and critics generally waned with the news of the Moscow-Berlin Pact of 1939, although nationally, communist influence and membership peaked in 1943-44. This defection suggests a certain superficiality in artists' ties to the party or Marxist dogma. What seems to have been at stake was a broadly liberal morality or ethic that could have assumed any one of several doctrinaire disguises, but by historical accident found its confirmation in radical politics. As the rise of Abstract Expressionism and its criticial literature occurred in the early to mid-forties, politics was still on people's minds, and there were still many points of contact between thinking of the thirties, including communism, and thinking of the forties. An expanded political awareness is perhaps the most outstanding legacy of the thirties to post-war American art.

> Whether we like it or not, after Marx it is no longer possible for anyone to delude himself that his attitudes toward art or society are a-political. What Marx accomplished was nothing less than the enlargement of the realm of the political until it embraced all human activities, attitudes and institutions. Thus Plekhanov, in *Art and Social Life* (1912), showed how the attitude embodied in the slogan 'art for art's sake'; far from being a-political, was in reality the expression of profound political despair.[19]

Early Reports of Postwar Paintings:
Kootz and Janis

Two critics of the mid-forties, Samuel Kootz and Sidney Janis, both gallery owners who were favorably disposed to the new American painting, published *New Frontiers of American Painting* and *Abstract and Surrealist Art in America* in 1943 and 1944, respectively. Both indicate the ferment in informed critical circles at the time. Although they share the desire to document new directions, their approaches, as well as the content of their books, diverge widely. Kootz was less interested in reporting the range of activity among New York artists than in supplying the reader with a definition of modernism, a problem which his text takes up in rather broad terms. Janis' text, on the other hand, is very brief and primarily concerned with identifying stylistic clusters within the new art. The particular value of the book is in its remarkably catholic and complete pictorial documentation of the younger New York artists.

Both Kootz and Janis are good examples of critics who recognized the need of "progress" in American art, but lacked a rationale of progress, as Rosenberg later would call it. As such, both reflect the impasse of American art of the thirties, and Kootz, especially, still kept one eye on developments among the political leftists. Even so, it is still clear that both Kootz and Janis were sympathetic to European modernism. This sympathy, however, did not necessarily entail a progressive criticism.

Samuel Kootz anticipated many problems taken up in later criticism, and at the same time clearly reflected the background of the war and the burden of what was still considered the provincial status of even the most advanced American painters. Slightly preceding the 1945 events noted in the foreward, and falling in the same year as Jackson Pollock's first one-man show at the Art of This Century Gallery, the Kootz book reflects less a need for a name for the new movement than for determining sources for what he saw as a potential rejuvenation of American painting. The following, excerpted from Kootz' famous letter to the *Times*, succeeded in provoking the "Bombshell Group" exhibition of 1942.

> Under present circumstances the probability is that the future of painting lies in America. The pitiful fact is, however, that we offer little better than a geographical title to the position of world's headquarters for art.

Consider what our present record is. The recent national roundup at the World's Fair was a representative cross-section, no matter how depressing it seemed. For all our big shots were shown, and a dilligent search unearthed the best men in each region. The inference was appalling.

I probably have haunted the galleries during the past decade as much as have the critics, because of my anxiety to see new talent, intelligent invention. My report is sad. I have not discovered one bright white hope. I have not seen a painter veer from his established course. I have not seen one attempt to experiment, to realize a new method of painting.

Isn't there a *new* way to reveal your ideas, American painters? Isn't it time right now to check whether what you're saying is regurgitation, or tired acceptance, or the same smooth railroad track?[1]

Kootz deplored the general lack of experimentation and believed that non-objective art of the puristic kind had ceased to be a profitable source for artists. At the same time he admitted that it might serve as the basis of some unforeseen development. The future, for Kootz, was ". . . something we could only determine if we knew the ultimate potential of Abstraction and Expressionism. These are the two great movements after Cézanne, and from them have come our most important living artists."[2] Gottlieb represents a particular case of this stylistic wedding. Classed more or less as a symbolist, Gottlieb is grouped with Graves, Bloom, Rattner, Avery and others. "Now it is a compromise between abstract geometry and expressionist freedom of emotion."[3]

Both these directions, the abstraction of the American Abstract Artists group and figural expressionism of the type of Bloom and Rattner, had just enjoyed a renaissance in the prior decade, and there is little doubt that, in this case, it is to these precedents rather than to previous European traditions that Kootz refers.

The combination of the categories, abstraction and expressionism, naturally recalls the term adopted for the new art only considerably later—that is, "Abstract Expressionism." This term, along with a few less popular ones, became the semi-official designation of the new American school. First used by Alfred Barr in 1929 in a discussion of Kandinsky, and later, in 1946, by Robert Coates in discussing certain New York artists, the term received its present currency during discussions at "The Club" which centered on a name for what some observers felt was a new movement.[4] The importance of the loose combination of these terms in 1943 for the later designation, therefore, merits some mention. Usually, when "Abstract Expressionism" is employed by later critics, it is tacitly assumed that something new (and often uniquely American) is implied; in other words, the emphasis is usually centered on traits without clear precedents or contemporary European analogues. Such an emphasis is implied by Kootz who sees the potential revolution in a similar light.

On the other hand, the residue of wartime vocabulary and WPA ideals amplifies the essentially conservative character of this criticism and recalls the rather boyish chauvinism and optimism so often encountered in discussions of WPA work: for example, Holger Cahill's writing of a decade earlier.[5]

> Our revolt against conservatism, against reaction, has made our painters part of a World movement to perpetuate liberal democracy—and to go forward in social thinking so that we may destroy forever the margins of poverty heretofore existent in that world.[6]

> It must become the purpose of the government to encourage our liberal arts.[7]

Kootz obviously sees the artist's role as a primarily social one and actually refers elsewhere to a ". . . searching to help manufacture a better state. . . ."[8]

In spite of his internationally-minded frame of reference and his reputation as a defender of modernism, Kootz seems to be viewing American art of the forties from a very general, abstract, and dated position. For example, his appraisal of Surrealism suggests his lack of sensibility of how stylistic trends were really moving.

> I believe it is as easy to trace the decay of France through the upsurge of Surrealism as it is to trace the rise of political Nationalism in America through its painting equivalent. . . . The decay evident in Surrealism results from an unhealthy conception of the function of painting.[9]

The present-day reader experiences dissatisfaction with his book because of its purely polemical and prescriptive goals. There is little, if anything, in his illustrations to support the book as a report of what was happening on the New York scene. Further, and somewhat like Greenberg's later prescriptions, Kootz tends to reduce everything to ideological terms of the most simplistic sort. "This is a war of ideas—of democracy against fascism."[10] Scanning his illustrations, one receives the impression that they do not really count; and indeed, the only name to reappear later as unproblematically "Abstract-Expressionist" is Gottlieb.

Even the AAA artists included are of a strictly purist or cubist-based kind. "It so happens that today the art of Picasso is the painting equivalent to our social thinking."[11] Kootz's reluctance to include the newest kind of informal or loose abstraction is more easily understood than his omission of work by Carles, Bowden, Lyall, Cavallon and other well-established, AAA-affiliated painters. Finally, his discussion of the immediate ancestors of American painting is so general that one cannot trace the artistic parentage of even the biggest and most conservative names then exhibiting.

Kootz's insistence on an international rather than American art may have led him to ignore some of the most significant talents of his time. Pollock,

Hofmann, Baziotes, Motherwell and several others discussed by Janis a year later are not mentioned by Kootz. That he took this modernist position at all, however, was important in view of the emphasis placed on the nationalistic schools by critics of the thirties—an attitude which, in the political officialdom of the forties, had outlived its stylistic counterpart in painting.

The political circumstances of this reaction in the forties involved the Communist rejection of Earl Browder's attempts at a coalition with the political center, or revisionism, as it was called. Under William Z. Foster the crisis of capitalism again became a major party interest and the old-line of revolution and class warfare was reinstated in 1946. The support of Henry Wallace as a third-party candidate later in the forties reflected this new line and also had the effect of alienating many sympathizers in the unions. All these factors, it should be noted, helped prepare the way for McCarthyism in the next decade.

Kootz's sarcasm over the "aggressive humility" of the official American spokesmen is certainly justified. One need only recall the antics of Representative Dondero of Michigan, recorded in the *Congressional Record,* whose speeches were entitled, among other things, "Communist Art in Government Hospitals," "Communism in the Heart of American Art," and "Modern Art Shackled to Communism." Further, the issue of the political texture of the American Artists' Congress was still in dispute.

That such political questions were still important as late as 1953 is shown by these depressing excerpts from the 15 November 1953 issue of *Art Digest.*

> One of the gaps which has existed in our overseas information effort . . . has been in the field of art, particularly in the fine arts—painting, sculpture, and to a lesser degree, architecture.

> Last week President Eisenhower, on the advice of the National Security Council, . . . gave the United States Information Agency a new mandate, as follows:

> 'The purpose of the United States Information Agency shall be to submit evidence to peoples of other nations by means of communication techniques that the objectives and policies of the United States are in harmony with and will advance their legitimate aspirations for freedom, progress and peace.'

> Now that makes it clear that we of the United States Information Agency are not interested in art for art's sake. . . .

> This is not to say that we wish to follow the Soviet pattern of showing only art which idealizes the American scene by the technique of the calendar school of painting. But it does mean that our Government should not sponsor examples of our creative energy which are non-representational to the point of obscurity.[12]

Sidney Janis, one year later, prepares us somewhat better for what is to come in *Abstract and Surrealist Art in America* (1944). Janis was already well-

known in art circles both as a collector and as a member of the advisory committee of the Museum of Modern Art (from 1934-48). His collection was shown in its entirety at the Museum of Modern Art in 1935, and in the manner of that Museum's retrospective exhibitions, was built along historical lines. This historically based perception of modern art reappeared in his book.[13]

To Kootz expressionism Janis added the non-rational or emotional ingredient of Surrealism, a school he had already manifested great personal interest in by his possession of Rousseau's "The Dream." Regardless of earlier tendencies to see abstraction and Surrealism as mutually exclusive, or as countermovements, he notes that they can be and, in fact, have been combined. Motherwell, for example, formerly associated with Surrealism, appears here as ". . . almost pure abstraction . . . in the *Spanish Prison*."[14] "Artists who embrace both directions have for a precedent the work of Picasso."[15] Although providing the reader with categories, Janis leaves the boundaries quite loose, and between the two poles of abstraction and Surrealism, the artist may move either way. In trying to determine the direction of events, Janis claims, and quite correctly: "It is evident that in the recent past the tendency has been away from pure geometric art."[16] As symptoms of this he cites increased variety of color and texture, modeling, and biomorphic shapes, thus ". . . making pictures of amorphous character with technical means that at times parallels the automatism of Surrealism" and "adding elements which may be best described as the visualization of subjective experience."[17] Janis repeatedly employs the term "romanticism" in this context and characterizes it as closer to Surrealism than to abstraction. His cognizance of Surrealism in the parentage of the new art is hardly surprising when one looks at the list of artists discussed. In contrast to Kootz's list, it consists, to a large extent, of names later to be associated with "Abstract Expressionism." His sources in Surrealism are quite unavoidable since he is writing at the time when the works of Baziotes, Tobey, Rothko, Gottlieb, Motherwell, and even Hofmann are particularly reflecting this influence. However, he also recognizes that these artists, among themselves or in comparison with others, do not represent a homogeneous group.

> The artists presented in this chapter are so grouped not because they are alike outwardly or derive from the same sources, but because consciously or otherwise they have the Surrealist approach.[18]

Janis' evaluation of Surrealism appears slightly uncritical from the point of view of the sixties since he gives little discussion to differences between the new Americans, either in intentions or pictorially, and the European Surrealists. At the time, however, Surrealism had several things to recommend itself, and Janis was obviously pleased with how things were going. First, Surrealism had some claim to scientific—that is, psychological—status, which for Janis was one of the hallmarks of twentieth-century modernism.[19] Further, many artists

who were unsure of what to call their art were secretly hoping it was Surrealism and not abstraction.[20] Understandably, the heavily implied debt to Picasso encountered in Kootz' book, especially clear in his selection of the illustrations, is minimized in Janis' book.

Janis also recognizes certain evidence external to the works themselves. Thus, the foundation of the Guggenheim Museum in 1939 with its large collection of early Kandinskys is duly noted. His comparison of Hofmann and Pollock is extremely sensitive and is based on the same perception that found so much popularity in later Pollock criticism—that is, the implication of a kind of crisis content. The passage below recalls Kootz' characterization of Gottlieb as both abstract and expressionistic.

> [Hofmann] is both abstract and expressionist: painted with such unpremeditated verve as to resemble the automatist method of Surrealism. Hofmann and Pollock paint with similar technique—yet they do not appear in the same category here, the line of demarcation being due to the difference of degree rather than of kind. The respective characteristics of their work are spontaneity versus obsessiveness.[21]

Of special importance in discussing either of these two critics, however, is the fact that neither had to go outside what was then considered normative critical practice. Both the sources and intentions of the artist were referred to historical precedent or various combinations of them. We get the feeling, even in Janis' perception of Pollock's obsessiveness, that he is not uncomfortable using the word. As in the case of Kootz' approximation of "Abstract Expressionism," "obsessiveness" was not yet a just cause for a revolution. It was only later that these concerns were recognized to be proper and/or necessary ones for advancing the new American case. The concepts themselves had currency but the artistic belief that was requisite to their critically designed exploitation did not.

Radical Criticism in the Forties: Greenberg

Clement Greenberg, associated loosely with the art world since the late 1930s, emerged from the same political background as Kootz. In the early forties this mutual identification with the political left gave their criticism many points in common. One of these was Greenberg's feeling that politics could not be separated from modernism. In "The Renaissance of the Little Mag" (1941), he discussed the function of the avant-garde press which he interpreted to be spokesmanship from a point of view.

> The function of a little magazine is to be an agent. In order to act as an agent and stir up good writing there must be some kind of positive notion, some working hypothesis, a bias in a particular direction, even a prejudice, as to what this good writing of the future will be like. As Kant says, you only find what you look for.[1]

The point of view taken must, for Greenberg, be governed by the present. Reviving old modernism is not enough, and it is on that point that he criticizes the policies of *View*. "From it we gather that the surrealists are unwilling to say goodby to anything."[2] For Greenberg, the old avant-garde, no less than old conservatism, was conventionalized and bankrupt. The only permissible point of view was politics—"not the politics of a particular party or faction, but thinking about politics." Although Greenberg recognized the current intellectual disgust with Stalinism particularly, and politics more generally, he felt that there had been no turning away "from the kind of emotion and the kind of literature politics helped produce."

> This persists because politics in some form or other cannot be eliminated today. All important questions become political questions in a much more immediate sense than in the past . . . public portent is political portent.[3]

This article reflected two clear positions with which Greenberg identified himself. The first is socialism and a Marxian philosophy of history. The second is an aesthetic position of purist reduction. His political position is expounded in "Ten Propositions on the War" (1941), in which he states that the real political issue of the day "is not the war itself—'for' 'against'?—but the war in relation

to social revolution."[4] The only solution is to "deflect the current of history from fascism to socialism. In the war or out of it, the United States faces only one future under capitalism: Fascism."[5]

Greenberg's belief in an inevitable movement or progress from one social stage to another had obvious implications for the choice of his second position—his philosophy of art history, and according to Greenberg, the redirections in art were no less predictable than in politics.

Greenberg's idea of progress in art had appeared a year earlier in "Towards a Newer Laocoon." The logic of the history of art was conceived as a constant struggle for each of the arts to purify its means. However, the forces in American politics which resisted socialism—the logical conclusion of social evolution—found their counterpart in American art as well. Indeed this confusion in the progressive history of art was a direct function of commodity-oriented capitalism. This maladjusted social basis of art led to popularization, or kitsch, and disturbed the purity of artists' investigations.[6] Hardly a new concern, as early as 1939 the threat of kitsch culture had already been the subject of Greenberg's well-known article entitled "Avant-garde and Kitsch."

> Because it can be turned out mechanically, kitsch has become an integral part of our productive system in a way in which true culture could never be, except accidentally. It has been capitalized at a tremendous investment which must show commensurate returns; it is compelled to extend as well as to keep its markets. While it is essentially its own salesman, a great sales apparatus has nevertheless been created for it, which brings pressure to bear on every member of society.[7]

> Kitsch's enormous profits are a source of temptation to the avant-garde itself, and its members have not always resisted this temptation.[8]

The threat to any particular art existed not only within the realm of politics, but within the arts themselves.

> Now when it happens that a single art is given the dominant role, it becomes the prototype of all art; the others try to shed their proper characters and imitate its effects.[9]

Greenberg believed that contemporary art had failed on both the political and the artistic levels—in the last case, by its surrender to literature.

> It was to be the task of the avant-garde to perform in opposition to bourgeois society the function of finding new and adequate cultural forms for the expression of that same society, without at the same time succumbing to its ideological divisions and its refusal to permit the arts to be their own justification.[10]

The avant-garde had failed. The importance of this for Greenberg's later criticism is well expressed by Poggioli.

[Greenberg] juxtaposed the concepts of avant-garde and of kitsch. . . . Greenberg established the connection on a level which was not purely critical or literary. As a leftist critic he maintained that avant-garde and kitsch were the cultural fruits, one as bad as the other, or a unique social, economic, and political situation, equivalent and parallel results, in the field of art, of the same stage of evolution or, better, the same phase of decadence in bourgeois and capitalistic society. We might sum up Greenberg's position, translating it into Spengler's language, by saying that the coinciding of avant-garde and kitsch shows that we are dealing with a Civilization now unable to produce a Kultur.[11]

For Greenberg, the contemporary painter best exhibiting the purity of means he desired, both in his theory and in his art, was Hans Hofmann. His "Painting and Culture" (1921) makes an instructive comparison with the 1940 Greenberg article.

. . . the difference between the arts arises because of the difference in nature of the mediums of expression and by the emphasis induced by the nature of each medium. Each means of expression has its own order of being, its own units.[12]

Greenberg has stated that his acquaintance with Hofmann's classes and lectures began in 1938-39, although he saw Hofmann's painting for the first time in 1944.[13]

Hofmann is indebted to, among others, Kandinsky, who had announced the following in 1912:

Consciously or unconsciously, artists are studying and investigating their material, weighting the spiritual value of those elements with which it is their privilege to work.[14]

Greenberg, himself, may owe Kandinsky a direct debt in his discussion of music and painting.

But only when the avant-garde's interest in music led it to consider music as a method of art rather than as kind of effect did the avant-garde find what it was looking for. It was when it was discovered that the advantage of music lay chiefly in the fact that it was an 'abstract' art, an art of 'pure-form.'[15]

Kandinsky has the following to say.

At different points along the road are the different arts, each saying what it is best able to say, by methods peculiarly its own. Despite differences, or perhaps even because of them, the various arts have never been closer to each other than in this recent hour of spiritual crisis.[16]

. . . the natural result of this work is a comparison of the elements of one art with those of another. Music is found to be the best teacher. For some centuries, with

few exceptions, music has been the art which has developed itself not to the repro-
duction of natural phenomena, but to the expression of the artist's soul and to
the creation of an autonomous life of musical sound.[17]

The relationship of Greenberg's political philosophy to his philosophy of
art history is similar to Rosenberg's to the extent that the former becomes a
metaphor for the latter. With Greenberg it is the historical mechanics, not the
historical hero, which is stressed. The value of his criticism, however, rests on its
authority as criticism, and not its political implications. Politics was important
as it determined what, in the history of criticism, Greenberg selected as useful
starting points. It further served to invest his choices of formal directions in
painting with a considerable moral weight.

Although stated in its main outlines as early as 1940, Greenberg's criticism
received its best formulation in "Present Prospects of American Painting and
Sculpture" (1947).[18] In many respects he must be regarded as a conservative
in this early stage and demonstrates many attitudes in common with Kootz.
Like the latter, he is loath to admit the importance of Surrealism and clearly
reflects his prior endorsement of the American Abstract Artists group. He was
aware, of course, that painters were faced with a new society and stated that
American bourgeoise industrialism had retarded artistic advance. Greenberg
claimed, moreover, that the seat of the trouble was the lack of a proper recogni-
tion of this crisis situation,[19] a situation which could be met only by a head-on
confrontation, which itself would become the backbone of the new art. Green-
berg, unlike various later critics, recognized that far from being indifferent to
recent painting cultures, the new Americans still depended almost exclusively
on School of Paris precedents. His complaint is that ". . . hardly anywhere
around him does he find, in either decor or activity, impulses strong enough
to send him further," and that he ". . . must live partly by time transfusions."[20]

Greenberg here restates the crisis situation provoked by the bourgeoise
and industrialism.

> In his effort to keep a step ahead of the pedagogic vulgarization that infects every-
> thing, and in his endeavors to locate the constantly shifting true center of serious-
> ness, the ambitious American writer and artist must from moment to moment impro-
> vise both career and art. It becomes increasingly difficult to tell who is serious and
> who is not.[21]

His solution, one based on historical precedent, is suggested by Impressionism
which itself prevailed by

> . . . implicitly accepting its materialism—the fact, that is, that life can be radically
> confronted, understood and dealt with only in material terms. What matters is not
> what one believes but what happens to one. From now on you had nothing to go
> on but your states of mind and your naked sensations, of which structural, but not
> religious, metaphysical or historico-philosophical interpretations were alone
> permissible.[22]

His expectations at this point clearly reflect goals similar to those of artists of the thirties such as Glarner and G.L.K. Morris. The latter, whose critical framework was almost wholly Cubist-derived, directly preceded Greenberg as art editor of *Partisan Review*.

This fact reinforces the suspicion that Greenberg was not formulating his early notions of history to justify Abstract Expressionism, but as an apology for the American Abstract Artists group. It is not difficult, in view of this, to see why Greenberg had some difficulty making Pollock, or, indeed, any abstract expressionist, fit into his formalistic scheme. It was that same foundation in purist abstraction, on the other hand, which allowed his criticism to fit so well in the sixties.

His examination of Jackson Pollock may clarify his position further. For Greenberg, Pollock represented one of the great American hopes (Plate 1).

> For all its Gothic quality Pollock's art is still an attempt to cope with urban life; it dwells entirely in the lonely jungle of immediate sensations, impulses and notions, therefore is positivist, concrete.[23]

Greenberg clearly indicates, however, that to the extent that his work is paranoid, resentful, or "Gothic," it is narrower.

> Pollock's strength lies in the emphatic surfaces of his pictures, which it is his concern to maintain and intensify in all that thick, fuliginous flatness which began— but only began—to be the strong point of late Cubism.[24]

To give force to his insistence on the relevance of tradition, Greenberg then suggests a formal genesis of Pollock's art: ". . . a Gothic, morbid and extreme disciple of Picasso's Cubism and Miro's post-Cubism, tinctured also with Kandinsky and Surrealist inspiration."[25] Hofmann's influence is also noted, ". . . essentially a positivist, immediate one," and his activity, Greenberg predicts, will be considered the most important in America between 1935 and 1945.[26] In contrast to the nihilism of certain later critics, it is clear that Greenberg, in 1947, was calling for new "artistic" values.

> A substantial art requires balance and enough thought to put it in accord with the most advanced view of the world obtaining at the time.[27]

> We stand in need of a much greater infusion of consciousness than heretofore into what we call the creative.[28]

In 1948 ("The Situation at the Moment") Greenberg enlarged, and in my opinion, slightly confused, his position of a year before.

Plate 1
Jackson Pollock, "Sounds in the Grass: Shimmering Substance," 1946
30-1/8" x 24-1/4", oil on canvas
Collection of The Museum of Modern Art, New York
Mr. and Mrs. Albert Lewin and Mrs. Sam A. Lewisohn Funds.

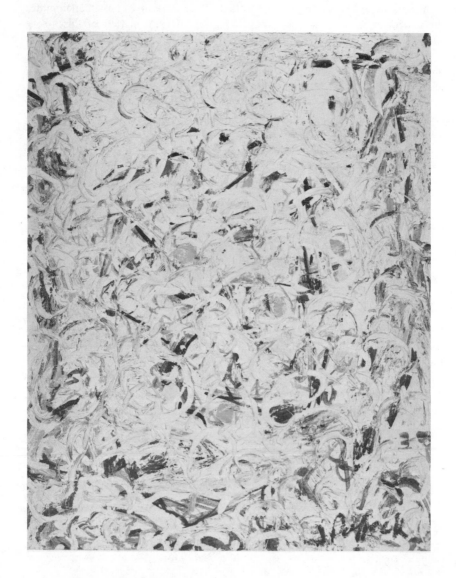

Destructiveness toward what we now possess as American art becomes a positive and creative force when it is coupled with a real longing for genuinely high art. . . .[29]

The American artist has to embrace and content himself, almost, with isolation if he is to give the most honesty, seriousness, and ambition to his work. Isolation is, so to speak, the national condition of high art in America.[30]

The insistence on destructiveness and isolation, offered up as urgently as they are here, maintains the high pitch of his writing. He detects in the artists an

. . . urge . . . to go beyond the cabinet picture . . . to a kind of picture that, without actually becoming identified with the wall like a mural, would 'spread' over it and acknowledge its physical reality.[31]

Here, we also get a more explicit referral to a cultural crisis.

American art is today involved in the general crisis of Western art, whose historic impulses, with all they carried . . . have ebbed away in Europe under the suction of events and a declining bourgeoise order.[32]

Besides the physical presence noted above, Greenberg proposes other traits necessary to a new art. The diminished space of flatness, for example, a direct function of the abstraction of the picture, must be compensated for by a bigger format. Most historically implicated in this tendency are Picasso and Matisse.

The attempt is being made to create a large scale easel art by expanding Matisse's hot color, raised several degrees in intensity, into the bigger, more simplified compositional schemes which he himself usually reserved for blacks, greys and blues—all this to be articulated and varied with the help of Picasso's calligraphy.[33]

Another of Greenberg's early statements, his contribution to a symposium in 1949, also bears consideration. In the symposium his essential position, consistent throughout the forties, is neatly summarized in the following way.

There is in my opinion a definitely American trend in contemporary art, one that promises to become an original contribution to the mainstream and not merely a local inflection of something developed abroad. I would define it as the continuation in abstract painting and sculpture of the line laid down by Cubism and broadened subsequently by Klee, Arp, Miro, Giacometti, and the example of the early Kandinsky, all of whose influences have acted to modulate and loosen forms dictated by Matisse, Picasso and Léger. An expressionist ingredient is usually present that relates more to German art than to French art, and Cubist discipline is used as an armature upon which to body forth emotions whose extremes threaten either to pulverize or dissolve plastic structure.[34]

As in 1940, the idea is expressed here, that ". . . the naturalistic art of our time is unredeemable as it requires only taste to discover."[35] Included in this category are Surrealism, Futurism, Neo-Romanticism, "Neue Sachlichkeit," Magic Realism, etc. . . ." pretexts, all of them literary or journalistic, to reintroduce what is essentially academic naturalism."[36]

Much has been written about the origins of Greenberg's notion of "self-criticism" in the arts, and, as in the case of his rival, Rosenberg, Greenberg seems to have numerous intellectual debts. Already mentioned are the similarities between his own criticism and that of Kandinsky and Hofmann. Excepting his own claim of descent, in a very general sense, from the "criticism of the Enlightenment," Greenberg has very little to say about the nature of his sources;[37] however, the reader receives the impression that as modern painting stands as a logical link in the progress of painting, so also does Greenberg's criticism represent a logical and progressive link in the course of the history of criticism. While Greenberg claimed Kant as his essential source, Calas has rightly noted that his ideas owe more to Hegel in reality, even though this influence observes its own limitation.

> As is known, it was Hegel, not Kant, who viewed art as being conscious of its own self, that is, of its spirit. For Hegel, spirit is consciousness on the level of self-consciousness. From a Hegelian point of view it might be said that art enters a period of self-criticism when it apprehends its spiritual fulfillment by becoming conscious, through experience, of its historical development. For those, like Greenberg, who do not believe that art can achieve independence by pointing beyond itself to the spirit, art's self-criticism would have to be justified on a non-Hegelian interpretation of experience. Greenberg thought he found a solution to the difficulty in Dewey's theory, which holds that pure experience is an aesthetic experience: . . . But the 'kind of experience' Greenberg has in mind is linked to a self-certainty acquired separately by each individual art: Hence 'the task of self-criticism became to eliminate from the effects of each art any and every effect that might conceivably be borrowed from or by the medium of any other art.'[38]

Notwithstanding the correctness or incorrectness of Calas' criticism, all this is probably not as meaningful as Calas thinks, for if one finds other, nonphilosophical sources for Greenberg's ideas, all the confusion goes away. Among these other sources one encounters Walter Pater. A few quotes from *The Renaissance* indicate the extent of Greenberg's debt to Pater (and, of course, to later formalists such as Fry and Bell).

> All art has a sensuous element, color, form, sound . . . each of these may be a medium for the ideal; it is partly accident which in any individual case makes the born artist, poet or painter rather than sculptor. But as the mind itself has had an historical development, one form of art, by the very limitations of its materials, may be more adequate than another for the expression of any one phase of its experience. Different attitudes of the imagination have a native affinity with different types of

sensuous form, so that they combine easily and entirely. The arts thus may be ranged in a series which corresponds to a series of developments in the human mind itself.[39]

Pater's discussion of sculpture is particularly purist in its outlook, even to the point of making a moral issue of what he views as any violation of the intrinsic attributes of the given medium. The moral issue was intensified in Greenberg's own criticism, although its basis in this later work is largely political. As the corruption of American artistic culture depended on the tradition of material- ism, the artist was obliged to seek art's own logical ends in spite of, or perhaps because of, his political situation. It was his political awareness which described the "rightness" or "wrongness" of the particular direction taken. Anyone who chose the wrong direction was not only doomed to historical obscurity but open to the charges of subversiveness.

> But why should sculpture thus limit itself to pure form? Because, by this limitation, it becomes a perfect medium of expression for one peculiar motive of the imaginative intellect. It therefore renounces all those attributes of its material which do not help that motive.[40]

A comparison of the following passages from Pater with some passages from Greenberg's "Towards a Newer Laocoon" of 1940 is instructive.

> All art constantly aspires toward the condition of music.[41]

> Therefore, although each art has its incommunicable element, its untranslatable order of impressions, its unique mode of realizing the "imaginative reason," yet the arts may be represented as continually struggling after the law or principle of music, to a condition which music alone completely realizes.[42]

Pater had not been unique in holding such beliefs. In 1877, Georges Rivière said something similar: "To treat a subject for its tones, not for itself—that is what distinguished impressionists from other painters."[43] Gauguin had gone a step further:

> I obtain by arrangements of lines and colors, using as a pretext some subject bor- rowed from human life or nature, symphonies, harmonies that represent nothing absolutely real . . . they should make one think as music does . . .[44]

Likewise, the Nabis had declared that a picture is "an object having its own laws."[45] Pater has been described, along with Oscar Wilde, as "an academic dandy [who] attempts to discipline feeling to art, bringing to literature an overbred sense of his medium."[46]

Nabi theory was important, in turn, for certain Cubists and purists. Gleizes and Metzinger still imply referents external to the picture when they claim that

"an object hasn't any absolute form. It has many; as many as there are planes in the domain of meaning."[47] But Gris refutes the outside object in the following.

> I begin by organizing my picture and then I define the objects. It is a matter of creating new objects that cannot be compared to objects existing in reality. It is precisely this that distinguishes Synthetic Cubism from Analytic Cubism. Thse new objects escape distortion.[48]

It was the ideas of Synthetic Cubism which formed the basis of AAA thinking in the thirties, and which provided Greenberg with his concept of Cubism.

The poets endorsed this ideas as well. The Cubist dealer Kahnweiler describes Mallarmé as a source of modern art equaled only by Cézanne.[49] Advising Degas on the composition of sonnets, Mallarmé said that "you don't write sonnets with ideas, Degas, but with words."[50] It was Kahnweiler's conviction that his poetry became most influential around 1907, when it was read by the Cubists. This belief is echoed by Robert Motherwell who says "the poet Mallarmé was responsible for the atmosphere in which Cubism became possible."[51]

In the twentieth century it was Valéry, who as late as 1938 "was lecturing on 'Poetry and Abstract thought,' asserting that verse is essentially a pure music liberating us from the world of objects."[52] Finally, there is T.S. Eliot, who Greenberg himself has called "the best of all literary critics."[53]

> In an essay of 1923 called 'The Function of Criticism,' Eliot writes that '. . . a critic must have a very highly developed sense of fact.' . . . If the implications of Eliot's practice itself are evidence . . . the prime fact about a work of literary art is not what it means but what it does—how it works, how successfully it works, as art.[54]

In seeking Eliot's sources, Greenberg suggests that he might have been influenced by the milieux in England of 1914 which produced the formalist critic Roger Fry.[55] While this is true, it is likely that the influence was from literature to the visual arts. Fry translated Mallarmé, and in his *Transformations* essay— "Some Questions in Esthetics"—had mounted a fictional debate with the positivist critic I.A. Richards, whose ideas had already appeared in his *Principles of Criticism* (1924). Greenberg undoubtedly owed a large debt to Fry himself.

Radical Criticism in the Forties:
Rosenberg

In 1935, during a peak period of Communist activity in America, Harold Rosenberg wrote the following, excerpted from a poem appearing in *Partisan Review*.

> who thrust his fist into cities
> arriving by many ways
> watching the pavements, the factory yards,
> the cops on beat
>
> walked out on the platform
> raised his right arm, showing the fist clenched
> 'comrades, I bring news'[1]

How and how much Rosenberg's criticism of the forties was affected by his political affiliations are complex questions. Rosenberg acknowledged his Communist affiliations in the thirties, but he also expressed his disillusionment with them by 1940. In the passage below, the reference is certainly political, but Rosenberg has lifted the message to the plane of a philosophical reflection on political man.

> The mirror of our age is loneliness
> and non-being: the flocks walk down in it
> And disappear. Here the ego, that illusion,
> Has no grapple with the earth,
> But finds glory absolute
> In passing neatly from one phase
> to another of power while the flesh,
> Hairy impediment puts by its avarice
> for the pure costume of the public role
>
> If ranks of young men their arms linked together
> In comradeship of the blank sky
> And the wordless joy of muscles
> Deploy like dancers in the breathless meadows,
> . . . that is not man in his stoutness evolved
> To elegance and honor. It is rather
> As if a football lifted itself off a table
> And took flight through a broken window.

> Pure and plastic, transparent and crying aloud
> They run squirting fire from toys,
> Then fade ineffectually
> As the buildings fall.[2]

It is the dilemma of this political man, cast in nearly existential terms, that became useful for Rosenberg's art criticism of the forties. As in the poem just cited, criticism became a dramatization of what had, in the thirties, been more purely political.

In a 1940 article called "The Fall of Paris," Rosenberg described what he considered the failure of "modernism" in any collective sense. It was the failure which forced the critical revolution in the forties to set its course along individual lines. The character of Paris, while it reigned as the capital of modernism, is described by Rosenberg in the following way.

> Thus the Paris modern, resting on the deeply felt assumption that history could be entirely controlled by the mind, produced a No-Time, and the Paris "International" a No-Place. And this is as far as mankind has gone towards freeing itself from its past.[3]

With the advent of the Second World War, however, modernism was relinquished for a "higher need."

> The higher need was anti-fascism. . . . The Paris left adopted the style of the conventional, the sententious, the undaring, the morally lax—in the name of social duty and the 'Defense of Culture'. . . .' Anti-fascist unity became everything; programs, insight, spirit, truth, nothing.[4]

Modernism did survive, Rosenberg maintains, but in military and propaganda techniques—not in the studios. "In that country [Germany] politics became a 'pure (i.e., inhuman)' art, independent of everything except the laws of its medium."[5] And it is among the defeated that ". . . sickly new worlds are born—Stalinist, nationalist Utopias, Catholic Cities of God, Social Credit Luna Parks. . . ."[6] What Rosenberg was describing, of course, was America—its failure in the realm of modernism and its success in the realm of capitalism.

In view of the fall of Paris and his own experience with government-sponsored art in the thirties, it is no surprise that Rosenberg was apprehensive over the social implications of art which so interested his contemporary, Greenberg. It is also to be expected that a political vocabulary should play such an important role in his criticism of later years—both because of capitalism's threat to the artist and because of politics' close identification with the "modern." Since the artistic community was no longer vanguard, everything now rested in the hands of the individual. The surrender of collective artistic goals logically entailed the surrender of collective artistic values.

However, when Rosenberg tried to develop an idea of what an artist should be in such a situation, certain positive and negative guidelines from his political experience provided the answer. "The pure costume of the public role," which appeared in his poem of 1940, was taken up as the explanation of the behavior of revolutionary men in "The Resurrected Roman" of 1948.

> Social reality gave way to dramatic mimesis because history did not allow human beings to pursue their own ends. They were thrown into roles prepared for them in advance. Beginning in a situation which they had not created, they were transformed by a 'plot' that operated according to certain rules. . . . It was the pressure of the past that took revolutions out of the 'naturalistic' prose of the everyday and gave them the form of a special kind of dramatic poetry.[7]

Seeking to take his new artist-hero out of this historical circle, Rosenberg turned to Malraux and Sartre for examples, as Greenberg was later to turn to Marx.

> M. Malraux also rejects the old actors and speaks on behalf of the possibilities to be drawn from the situation through action . . . But the image of Malraux is more revealing historically than the magic of Sartre. Sartre, and this is vastly to his credit, is genuinely out in the open; he speaks for the living individual who has not yet won a place in the historical drama. While his position implies the hero, as a human being he will resist him.[8]

In 1947-48 Harold Rosenberg issued what was undoubtedly the most radical proposition on the new art to that date in *Possibilities I*.

> Art for them is rather the standpoint for a private revolt against the materialist tradition that does surround them.[9]

> Not one of these painters shows the slightest sentiment about his own past. Nor, perhaps what is even more unusual, for the past of the art of painting as a tradition.[10]

In face of great odds the new artist was revolting against the materialist tradition which threatened to collapse the old order, a crisis that precluded reformation along collectively endorsed lines. New art, then, aspired of necessity ". . . not to a conscious philosophical or social ideal, but to what is basically an individual, sensual, psychic and intellectual effort to live actively in the present"[11] (Plate 2).

This prefigured Rosenberg's approach in his 1952 article, entitled "The American Action Painters," in which he threw out traditional aesthetic criteria as possible measures of this school and disclaimed the material object as the major consideration of painting in favor of the *act* of painting.[12] With this position, it mattered little what the medium was that the action was performed through; it was rather the nature of the act being performed that was important.

Not only "art," but also the painting assumed little importance here. (Even the painting values were questionable, since it was difficult to logically require any specific medium for the act—unless one wanted to assume that a blank canvas, brushes, rags, tubes of paint, etc., actually induced acts of such a nature, in the literal sense, whereas other material implements would not.) This was clearly anticipated in *Possibilities* when Rosenberg says the following.

> Such practice implies the belief that through conversion of energy something valid may come out, whatever situation one is forced to begin with.[13]

Rosenberg's lack of commitment to the painting tradition and his concern that political matters will be construed as "more serious than the act that sets free in contemporary experience forms [which] that experience has made possible,"[14] suggest that it was not only traditional artistic values but artistic values in any form which he distrusted. It is questionable whether Rosenberg wanted to redefine aesthetic categories of values to include the ones he introduces; "The question of what will emerge is left open."[15] Rosenberg's shift might be described as one from pure artistic value to pure value, for there is never any question of the value of what emerges, but only the question of the nature and location of the value. Rosenberg's interest in such a politically dramatized man is still evident in 1962.

> can one doubt that it was the challenge to action on the streets that was to lead in the next decade to the response in practice that the actions of the artist took place on the canvas? To the pragmatic ideologies of the Depression the pragmatic response of art was to be Action Painting.[16]

Politics was not solely responsible for Rosenberg's criticism, of course. Rosenberg himself has pointed out that his political commitment was never complete because his generation was "chronologically, as well as temperamentally on the edge between two generations and actually [a] stranger to both."[17] The two generations were the political one of the thirties and the preceding and modernistic one with Parisian inclinations.

In 1949, in an introduction to Wittenborn's edition of Raymond's *From Baudelaire to Surrealism* (1935), Rosenberg suggests the relationship he holds to modern French poetry. According to René Welleck, the book "is the fountainhead of a conception of criticism which aims less at an analysis of a work of art than at the discovery of the particular 'consciousness' and the existential feelings of the poets."[18] Speaking from a surrealist position, already betrayed in 1935— "they run squirting fire from toys"—Rosenberg is anxious to interpret all modern French poetry from this point of view. Mallarmé and Valéry, although "they seem direct opponents of the radical dadaists or surrealists, whose method is to pick up in the streets a word that has never been in a poem before," share many of the newer poets' motives.[19]

Plate 2
Jackson Pollock, "Cathedral," 1947
71-1/2" x 35-1/16", mixed media on canvas
Dallas Museum of Fine Arts
Gift of Mr. and Mrs. Bernard J. Reis

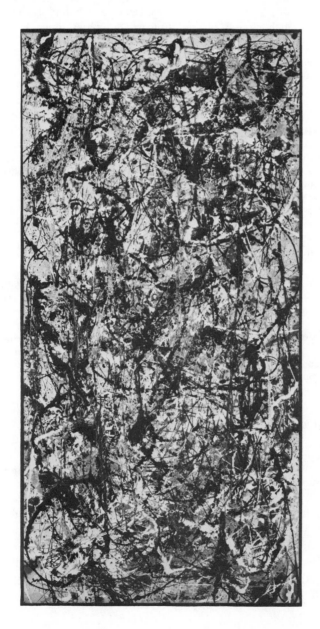

> Isn't their motive the same as that of the dadaist who invokes into poetry 'sardine can' which is nothing else than experience? All the French alchemists are after the same thing, the actuality which is always new . . . their poetry is an adventure, through and through. It cannot be written without placing their lives in jeopardy.[20]

A quick examination of Alfred Barr's introduction to *Fantastic Art, Dada, Surrealism* (1936) reveals many key concepts which find their analogue in Rosenberg.[21] Such phrases as the "atmosphere of breakdown," "there is only awareness," and "Dada was the sickness of the world" could be incorporated into Rosenberg's criticism with no modification whatsoever.

Rosenberg's special debt to Dada, recently reported in an interview with Motherwell, hardly comes as a surprise.

> A. Actually the notion of 'action' is gratuitous. A critic's finger in the stew. It was taken by Harold Rosenberg from a piece by Huelsenbeck. . . . At that time I was editing 'Dada' proofs of Huelsenbeck's which ultimately appeared in the Dada anthology as 'En Avant Dada.' It was a brilliant piece . . . Harold came across the passage in proofs in which Huelsenbeck violently attacks literary esthetes, and says that literature should be action, should be made with a gun in the hand, etc. Harold fell in love with this section, which we then printed in the single issue that appeared of 'Possibilities.' Harold's notion of 'action' derives directly from that piece.[22]

Following is a passage of the Huelsenbeck which Motherwell referred to, and which was included in the only issue of *Possibilities*.

> The Dadaist should be a man who has fully understood that one is entitled to have ideas only if one can transform them into life—the completely active type, who lives only through action, because it holds the possibility of his achieving knowledge.[23]

> . . . I obtain an impulse which starts me toward direct action, becoming the big X. I become directly aware that I am alive, I feel the form giving force behind the bustling of the clerks in the Dresdner Bank and the simple-minded erectness of the policeman.[24]

The following, from Valéry, shows why Rosenberg felt this close identification.

> O who will tell me how through existence my person has been preserved in entirety, and what thing has carried me, inert, full of life, and charged, with spirit, from one boundary of nothingness to the other.[25]

The similarities between Dada's and Rosenberg's positions do not end with their employment of overlapping vocabularies. Rosenberg's criticism also functioned in much the same manner as certain Dadaists' criticism. Alfred Barr, in his 1936 discussion of Dada and Surrealism, has this to say about Duchamp's and Picabia's initial appeals for those endorsing a completely destructive philosophy.

In truth, their poetic temperaments inclined them toward the marvelous, toward the fathomless depths of the subconscious recently probed by Freud, rather than to a total disorder. They needed, however, some way of making a clean slate and of getting rid of what was in their way. Dada, a phenomenon of the post-war crisis, they welcomed as a way of salvation. . . . And although the word Surrealism was already currently used between Breton and Soupault, . . . the group of Litterateur, deeming no other action possible for the moment, surrendered to Dada.[26]

Like the Dadaists, Rosenberg possessed strong polemical instincts which he never hesitated to use.

At the same time Rosenberg realized the extent of his French debts, he also realized the unique position of the American poet.

About 15 years ago René Taupin pointed out that poets in America were lucky in having a lingo that hadn't yet settled into a literary language. The revival of American poetry around World War I and the twenties depended on an awareness of this luck, in which the French consciousness played a leading part.[27]

Rosenberg felt that American poets lost this advantage in the thirties and forties, initially because of their interest in politics, and then, later, because of their interest in tradition. As always, tradition for the American meant England.

The chief Pied Piper to the *Oxford Book of English Verse* was, of course, Eliot . . . the consideration in Eliot of poet and academician word-specialist and snob, made him destructive in the moment of America's decline in poetic and individual independence. With his famous formula of the supremacy of tradition over individual talent, he succeeded in making poetry appear as a thing, to which a certain caste had given itself as to a minor trade.[28]

It was in the interest of reviving what America had lost that Rosenberg turned, as had other poets, to American frontier historiography. A comparison of his article "Parable of American Painting" with William Carlos Williams' "The American Background" reveals great similarities, and in both cases, their debt to traditional American frontier historiography. Both authors are concerned with the condition of the man transplanted to a new environment, and how he successfully copes with it. The following two quotes are from Williams and Rosenberg, respectively.

The significance of Boone and of the others of his time and trade, was that they abandoned touch with those along the coast, and their established references, and made contact with the intrinsic elements of an as yet unrealized material of which the new country was made. It is the actuality of their lives, and its tragic effect upon them, which is illuminating.[29]

To be a new man is not a condition but an effort—an effort that follows a revelation in behalf of which existing forms are discarded as irrelevant or are radically revised.

The genuine accomplishments of American art spring from the tension of such singular experiences.[30]

In the same spirit, Rosenberg goes on to say that ". . . Coonskinism is the search for the principle that applies, even if it applies only once. For it, each situation has its own exclusive key."[31] Rosenberg's debt to American frontier historiography, as well as existentialism, is quite clear at this point.

At the same time, however, the very extremity of their isolation forces upon them a kind of optimism, an impulse to believe in their ability, to dissociate some personal essence of their experience and reserve it as the beginning of a new world. For each is fatally aware that only what he constructs himself will ever be real to him.[32]

Jacques Barzun perhaps comes closest to capsulating Rosenberg's position by subsuming his nihilism, individualism, and existential overtones all under the concept of "liberation."

. . . what the public is responding to is the promise of liberation, it is the idea of 'Enough! Good-bye to all that.' The duty towards art—to love it and understand it, to be independent, to side with the best, to catch allusions, to interpret myths, to remember names, titles, influences, versions. . . . These infernal commandments of our religion of art became dead letters the moment there is no art to behold, no ideas, words, purposes, or principles to follow, but simply an event in somebody else's life, of which no special cognizance need be taken. To know this is like experiencing the relief that Henry James found even in the death of those best loved; it is the license to practice a serene and silent atheism.[33]

Rosenberg's criticism coincided with the future course of painting and the careers of artists such as Baziotes, de Kooning and Pollock whose importance was not altogether clear in 1947. He seems to have taken serious account of the artist's statements, or they of him, for little strain exists in Rosenberg's work between what is happening and what he wants to happen. Greenberg, on the other hand, has something in mind, which to his way of thinking is prior to what is actually going on at any particular time; this something is the immanent succession of historical styles. What continued to happen in painting seemed to reinforce Rosenberg's speculations. This fact, along with the artists' insistence on a content, may account for the change in tone detectable in Greenberg's 1948 article in which isolation, destruction, urgency, and the general crisis situation are stressed. By 1949, he is able to condone (although in a larger formalistic context) ". . . emotions whose extremes threaten either to pulverize or dissolve the plastic structure."[34] Although Greenberg preserves his historical machinery for explaining formal matters, in 1948 there is much less talk about what a work of art "should" do.

The differences implicit in these critics' general positions are also clear from their examinations of specific works. Rosenberg's criticism of the specific

work, however, is not what one would expect from his more generalized essaying. In discussing "Cyclops" (1947), by Baziotes, Rosenberg reveals his heavy dependence on surrealist critical metaphors. His surrealist sources are no surprise considering the nature of his earlier poetry, but the fact that his critical images are still "magical" is surprising in view of his "Statement" (also in *Possibilities I*), which is much more indebted to Dada and existentialism, and where "the question of what will emerge is left open." In the above named work, Rosenberg sees a "Creature . . . coming forward," made by an artist "inspired by a concentration upon that in a scene which is either absent or scarcely able to make itself noticed."[35] Rosenberg's references to the real attributes of the work are given force, not by the real referent in the picture, but by the symbolist associations provoked by his prose.

> . . . thus a curious appeasing vibration flows through his colors, whose textures seem to absorb silence as if his paints had been mixed in a medium of sleep.[36]

It is the "presences" and "depths" in a Baziotes which are important, and not the means of the painter. Indeed, Rosenberg conceives of Baziotes as the "vehicle," not as the active agent itself. Rosenberg's use of a ready-made surrealist vocabulary to discuss real paintings and his choice of Baziotes as a subject are probably no coincidence, even though Baziotes did not represent his notion of the artist as well as, say, de Kooning or Pollock.

Greenberg is more consistent in his discussion of Pollock about a year later. In regard to "Number One" (Plate 3), a work he describes as a "huge baroque scrawl in aluminum, black, white, madder and blue," he notes a surface pattern of apparent monotony which, upon a closer examination, "reveals a sumptuous variety of design and incident."[37] He notes, among other things, the containment of the composition—"as well contained in its canvas as anything by a Quattrocento master"—and the balance achieved in his verticals and horizontals. This last virtue "avoids any connotation of a frieze or hanging scroll and presents an almost square surface that belongs very much to easel painting.[38]

Greenberg's nouns include surface, containment, verticals, horizontals, and other real traits of the work, and these are all interpreted in their most literal sense. The only reference to something not embodied in the painting itself is, significantly enough, another (Quattrocento) work of art. The stress he lays on containment and surface reflects his basically cubist aesthetic, at the same time that his recognition of the "baroque scrawl" proves that his aesthetic has not limited his perception. This last claim is less easily made for Rosenberg's criticism of the same date. It should be stressed, however, that in neither the case of Rosenberg nor Greenberg did the analysis of the specific works constitute the real value of their respective critical systems. The later belief that it

should have accounts for Greenberg's greater popularity in the later fifties and sixties.

It is clear that the new criticism appeared about 1945, at the time the "need" for a new criticism was voiced. Implicitly this means that new painting required new criticism—which perhaps it did. But this last assumption may be independent of why the new criticism actually appeared or why it appeared *the way it did*. It is indisputable that art was becoming an acceptable area for such a revolutionary critical enterprise, but may not have been its real cause. That this is a possibility is suggested by the fact that the call for new criticism came from official or conservative organs. Coates, Janis and Putzel are the people who represent the "progressive establishment" and who wanted a new "classic" criticism—that is, they wanted spokesmen for certain new art, but wished to maintain the traditional critical apparatus. But, as we have seen, the new criticism was delivered, at least in the case of Rosenberg, in a nonofficial idiom. It is curious that the section of the community that wanted a new criticism did not seem to realize that accomplishing this might entail (or at least encourage the reappearance of) avant-gardism. I believe this confusion goes far in explaining why Rosenberg's subsequent following was limited. It was precisely Greenberg's distrust of the avant-garde which fostered an establishment and a critical "academy" in the sixties.

5

A Cross Section of Criticism in the Forties

Greenberg and Rosenberg represent the poles around which most subsequent and progressive criticism turned. Likewise, they were the major targets of critics in the fifties, and especially in the sixties, who began discussing the critical rather than the painting tradition. All this does not mean that middle-ground or conservative criticism was unusual in the forties—it simply did not entail the enthusiasm or partisanship of Rosenberg's or Greenberg's positions. James Thrall Soby's "Some Younger American Painters," in *Contemporary Painters* (1948), is an example of positive and intelligent, if somewhat less ambitious, writing.[1] I shall here indicate a cross-section of critical opinion favorable to Abstract Expression in the forties; however, the kind of easy acceptance of Abstract Expressionism by traditional critics in the fifties was still something of an exception in the forties.

For James Thrall Soby, writing in 1948, there was a detectable trend in American art.

> Surrealism seems to be dying out as a formal movement in this country, though its rejuvenation of art's imaginative faculties remains a major and pervasive contribution, and has affected many younger American artists.[2]

Soby does little to explain the premises of what later critics saw as new and different, but we can detect something of this in his remarks on individual artists, for example, Pollock, Motherwell, Gottlieb, Baziotes, Rothko and Stamos. He does not mention a revolution even though he can detect in Pollock ". . . Baroque exuberance, his willingness to forego calculation and the niceties of balance in favor of primary emotional impact. His intimacy with the oil medium was rapt and without caution."[3] Soby counts Pollock as a Hofmann student and recognizes his maturity as early as the 1943 exhibition at Art of This Century. Not being a revolutionary did not preclude accurate perception. As in the case of certain earlier critics, Soby anticipates the artistic character of certain painters with remarkable accuracy. Rothko, for example, although nonobjective, he classes with the "sensibility" tradition.[4] His evaluation of Motherwell, on the other hand, as ". . . not at all stylish . . ."[5] might meet resistance today on precisely that account. Late abstract cubist developments are cited as the origins of these new painters, who ". . . paid particular heed

to the college and to those aspects of abstract art which touch upon the enigmatic and in which there lingers some hint of humanist reference."[6] If we question Soby's lack of reference to "anxiety" and "necessity" postulated by Greenberg and Rosenberg, a clue to the omission may be provided in the first passage quoted where he observes that surrealist art rejuvenated art's *imagination*. This choice of words carries an implicit challenge to the crisis situation described by Rosenberg, whose "conversion of energy" must certainly depend on surrealist procedure. Soby ends with the following and tantalizing (if slightly belated) suggestion.

> The period is too recent for anything like careful evaluation; it is ripe only for tentative, personal opinion for a journalistic account of the younger Americans whose work has appeared conspicuously in New York during the time, not yet ended, when that city has been the most active art center in the world.[7]

In 1949, the English critic Denys Sutton ("The Challenge of American Art"), attached abstract art to the American scene with a slightly different twist and in many significant ways, especially in his debt to frontier historiography, resembles Rosenberg.

> Just as he has evolved out of language a new one which corresponds to his technological needs and is based on his dislike for elegance, so now he is attempting to evolve a new pictorial language permitting him to forget his puritanism and achieve the relaxation he craves.[8]

Further, and as a function of the American scene, paintings are made for large spaces.[9] American painting, then, is a vernacular idiom developed to cope with a new situation. The content is the relationship of the individual to society. While Sutton recognizes that this is not an exclusively American problem, he inclines to think that its solution may be best effected in America where the realization of the crisis is more pervasive. Painting, for Sutton, is an expression of this situation, realized through the vehicle of personality. Like Hess, somewhat later, Sutton thinks abstraction is a contradiction of terms, if by it is meant "divorce from the object."

> . . . The best of the abstract painters create a painting world which is a projection of their own personalities. It is at its most powerful when expressing liberation from some particular theme or frustration; abstract painting is related fundamentally to the stream of consciousness.[10]

His emphasis of liberation and stream of consciousness strike the key note of much of the later literature, and explicitly claim what is implicit in some of Rosenberg's earlier work.

In discussing the character of the work itself, Sutton notes its spontaneity,

immediacy, and free use of color, all related ultimately to Kandinsky—a painting ". . . related, as Kandinsky showed, both in practice and theory to definite emotions,"[11] and which stresses the primacy of the search itself.[12]

While Rosenberg was unclear about the exact significance of the artist's act, and Greenberg called for an art that would act to release the tension of urban life, Sutton described a function that ". . . verges on the therapeutic."

> A painting by Jackson Pollock, for instance, possesses two meanings; one in terms of pure color and calligraphy . . . and another in terms of the need to secure deliverance from certain images. The artist . . . is in constant struggle with himself and his material.[13]

Sutton concluded that, although ". . . filled with paradoxes and contradictions . . . America is to be envied its possession of a metaphysic."[14] It is precisely this location of an American metaphysic which distinguishes him from Greenberg's historical determinism and links him, in a very general way, to Rosenberg.

The criticism of Greenberg and Rosenberg (to a lesser extent, Soby and Sutton) might be called "designed" criticism in the sense that the critic has invented a design to interpret or see a work of art through. The subject of the criticism, that is, the paintings, cannot logically be viewed then, as the only or even the most important historical basis of the designs these critics formulated.

Unlike this criticism, however, routine "reviewing" appearing in the popular art magazines (notably *Art News* and *Art Digest* in the forties) seemed more to presuppose the existence of criticism than to practice it. The reader usually knows that the author approves or disapproves of the works, but almost always lacks the generalizations which ultimately premise the reviewer's position. It is this last level, of course, that the progressive critics were most interested in re-examining. Therefore, in the reviewers' descriptions and in their comments, usually directed at individuals (there were no "group" shows recognized as specifically centering around "Abstract Expressionism" this early), they often show great similarity to the critics with critical designs. It is the absence of working premises (which is the only way of criticizing in collective terms) which prevents these reviews from being "criticism" in the sense discussed here. The vanguard critics of the forties recognized this difference when they implicitly rejected "reviewing" in *The Tiger's Eye* by the inclusion of Henry James' acid article on the same subject.[15]

Perceptiveness among the reviewers could be cited at length, but one or two examples will serve the present purposes. In May of 1946, *Art News* reported the following.

> Today Pollock still uses an automatic technique, pushing totemic and metaphorical shapes into swirling webs of pigment. However, he has also developed his 'simplified'

new manner. Larger, more representational shapes are placed against flat mono-
chrome backgrounds. Clarity increases at the expense of motion. This is a logical
development in Pollock's attempt to create a new, abstract mural style which will
sustain a complexity of plastic and literary elements previously found in small
three-dimensional easel paintings.[16]

Jules Lansford, in February, 1948, reviewed Baziotes in the following way.

Baziotes starts with an inner visualization of a natural image; then he becomes pre-
occupied with plastic problems, and by the time the painting is finished, there is
but a glimmering of the image left. Evaluating him within the limits of his self-
imposed purpose (which is the only valid point of critical departure, assuming that
the artist's purpose is valid), it must be concluded that he succeeds in exploiting
these plastic problems.[17]

These two reviewers may well owe debts to Greenberg and Rosenberg (and
Baziotes' own statements), but the positions of Greenberg and Rosenberg
could certainly not be inferred from them without prior knowledge.

The limitations imposed on routine reviewing frequently encouraged
disagreement with the new criticism. Writing for *Art Digest,* Riley showed
considerable reluctance in accepting certain of their notions, especially ones
that depended ultimately on psychology.

Is it too much to ask of a reviewer of art exhibitions that he approach paintings
subconsciously, the while remaining fully conscious of his responsibility to trans-
late his experience into a comprehensible report? The question is raised by the
increasing insistence of forward writers these days that only through such an ap-
proach can we expect to realize certain painted expressions.[18]

In the same issue, Riley reviews Gottlieb in a largely favorable light, but suggests
that the subconscious states of mind are being a little overworked by spokesmen
of the new art.

Riley's objection betrays her feeling that the reviewer's job makes certain
viewing procedures impractical—that there is less time here for contemplative
viewing than with the more literary spokesmen for the group, of what she
dubbed the forward writers. She also reflects an impatience with a criticism
which is not encumbered as her own is, with the task of addressing itself to art
objects. Prescription may be acceptable in the sweeping sort of criticism penned
by Greenberg, but it is clearly inappropriate in the context of an exhibition
review where prescription looks after the fact.

In this role as a critic of critics, Riley anticipates one of the most popular
gambits of the opponents of radical criticism in the fifties—that is, that the
critic was not addressing the work of art. As we have seen, even Greenberg,
who subsequently gained much popularity by meeting this particular criticism,

permitted his philosophy of history to obscure this point in much of his earlier writing.

It is worth noting, however, what Riley, coming to Pollock without criticism of a "designed" sort, has to say about him. The following are remarks made about individual works in the show. "What it means or intends, I've no idea." "Further than this I can not go in comments for I really don't get what it's all about."[19] This seems to be the limitation of routine reviewing, and is doubly revealing since she had just claimed the following.

> . . . he seems to run into no resistance from the medium and no anxiety rears its head between the first flush of purpose and the ultimate achievement of it. But I feel a sort of belligerence in the partnership of paints and Pollock towards all other things—which includes the subject, and you and me.[20]

Only a few years later statements like this qualified as "What it was all about," particularly among critics of Rosenberg's persuasion.

The importance of mentioning the review at this point (it will not be discussed in the fifties and sixties) is that, excepting "designed" criticism, it was the only literature willing to handle the new art. Abstract Expressionism had not enlisted the interest of the article writers as yet—at least, in any of the large circulation art magazines.

A rash of symposia in the late forties, although reflecting little in the way of vanguard criticism, did somewhat increase the attention given the new painters, and perhaps to a lesser extent, their identification as a group. This popularization, however slight, undoubtedly had the effect of encouraging the growth of popular criticism, evincing assurance as it did, of a popular audience— a phenomenon which assumed particular importance in the early fifties.

In 1949, a symposium was held in order to determine "The State of American Art."[21] The range of critics participating was vast and represents a near complete cross-section of opinion (Abell, Barr, Barzun, Baur, Cahill, Frankenstein, Goodrich, Greenberg, Hamilton, MacAgy, Janson, Rich, Soby, Trilling, Devoluy, and Heron). On the basis of a simple head count, the final conclusion of the group indicated that little was happening of any noteworthy originality. Only three of these critics—Barr, Greenberg and MacAgy—took serious exception to the notion that American painting was still a hopelessly provincial affair. Barr typified the less pessimistic accounts with the following.

> I do not think that there is a single well-marked trend or direction in American art today. There is, however, a strong, broad, and diversified movement toward abstraction, often highly original in character and affecting many older, well-established artists as well as younger ones.
>
> I would say that American painting stacks up against the old world very well indeed.[22]

Barr seems to have something in mind but he does not tell us exactly what. MacAgy noted the new interest in myth and primitivism, but also located an idea about space which has received much discussion in the later literature.

> It is possible that pictorial metaphor could allude to a kind of dimensional idiom which would accord more with twentieth century thought than with the three dimensional instrument inherited from the Renaissance. Its expression marks an attitude rather than a style.[23]

He particularly mentions Rothko and Still in this respect, and it is these two painters who, along with Newman, became the targets for a similar kind of remark frequently voiced in the later literature. Something even more symptomatic of the situation in 1949 is mentioned merely in passing. Speaking of the mutual influence among painters and writers, he mentions that ". . . Greenberg's espousal of Jackson Pollock's work must have been useful to that artist."[24]

A year earlier, Abstract Expressionism had received enormous popular currency in a symposium organized and published by *Life*. As in the symposium discussed above, critics were reluctant to make positive assertions about the art. After the results were in, Greenberg's plea to the contrary notwithstanding, editor Davenport concluded that the critics showed considerable confusion, even among members of the same camp, and were unable to erect reliable standards of evaluation.[25]

Another symposium, organized by Douglas MacAgy in 1949 ("The Western Roundtable on Modern Art"), was accompanied by an exhibition including much work by the Abstract Expressionists, although the painters were not discussed in the sessions, either individually or as a group.[26]

The statements of the artists seem to occupy a position somewhere between the reviewer and the progressive critic. Unlike the critic, the artist's stake is not in criticism, and it is not his primary goal to advance a literary idiom. Unlike the reviewer, he is not harassed by deadlines, poor conditions for viewing the work and the reviewer's usual lack of space. On the other hand the artist shares traits with each of these enterprises. Like the critic, he feels compelled to justify his work "from the ground up" (this is not inconsistent with the fact that some artists feel that art requires no linguistic justification, itself a much discussed notion). Since the artist's primary job was to make art, however, he tended to be intellectually eclectic upon comparatively conservative sources. This puts him in a position somewhat like the reviewer of not raising new criticism for new occasions. He is generally satisfied with finding a traditional position which, with slight modifications, can be accepted as a fair literary equivalent for what he, the artist, is producing.

The thing that distinguishes the opinion of the artist, at least superficially,

is the fact that if anyone understands the painting, he, the producer, surely must. The logical difficulty with this position is patently clear, however. If the artist makes a "new" art which has any real claim to newness, his conservative sources must necessarily fail as criticism.

On the other hand, it is not always clear that the critics themselves are advancing new criticism in the interest of some new art. Indeed, one may fairly suspect that this enterprise, like painting itself, leads something of a life of its own. This is simply to say that no single "kind" of author guarantees satisfaction in terms of understanding the work of art. If for no other reason than this, the artist's critical opinions become worth examining at least briefly. It is curious in this respect that the artists's expectations of criticism may seem to conform more nearly to the function supplied by philosophy's classical definition. This may particularly be the case in the early stages of a movement (critical or artistic) when the polemics of critics reach their functional peak.

The concern over the object itself, and the lack of a stake in "progressive" criticism, as such, often permits the artist to give surprisingly balanced accounts of what is going on. The following passages written by Robert Motherwell in 1944, although demonstrating a certain coolness, have little in common with the historical appraisals of Abstract Expressionism encountered in the critics of the sixties. Whatever "accuracy" there is in Motherwell's description is partially due to the fact that, as the pseudo-official spokesman of the group, his early writing carried a certain prescriptive power with it. Its influence on later artists' statements is certainly probable in cases where painters shared his symbolist orientation.

> Empty of all save fugitive relations with other men, there are increased demands on the individual's own ego for the content of experience. The ego can draw from itself in two ways: the ego can be the subject of its own expression, in which case, the painter's personality is the principal meaning expressed; otherwise the ego can socialize itself—i.e. become mature and objectified—through formalization.[27]

Motherwell not only addresses the real (or potential) existential dilemma of modern man, but he also separates the new American answers from the doctrinaire surrealist answers to the dilemma. Formalization for Motherwell was not a matter of purist reduction (as it was in the case of the AAA spokesmen and early Greenberg), but had more in common with the "School of Paris." He criticized the Surrealists on two major grounds, the first of which involved their "destructive" or anti-aesthetic Dada ingredient.

> They have been the most radical romantic defenders of the individual ego. Yet part of their program involves its destruction. Where the abstractionist would reduce the content of the super-ego to the aesthetic, not even the aesthetic has value for the Surrealists . . . This is the Dada strand in the fabric of Surrealism.[28]

The other unfavorable aspect of Surrealism was its lack of specific direction.

> The fundamental criticism of automatism is that the unconscious cannot be directed, that it presents none of the possible choices which, when taken, constitute any expression's form. To give oneself over completely to the unconscious is to become a slave.[29]

Motherwell's rejection of certain logical conclusions of Surrealism came after a period of experimenting with precisely these conclusions as formulated by Matta, about 1940, with whom he had enjoyed fairly close contact. It is a matter of record that Motherwell had approached Pollock with these ideas, and that the latter had exhibited the same distrust.[30] Even among the "masters," contended Motherwell, automatism ". . . is actually very little a question of the unconscious. It is much more a plastic weapon with which to invent new forms."[31] The possibility, even necessity, of choices, an idea given its full existential apparatus by Harold Rosenberg in *Possibilities I*[32] and the 1952 article on "American Action Painters,"[33] figures large in many subsequent statements by various artists.

The external world did not provide the content of experience for Motherwell, a fact requiring the artist to ". . . draw from himself." Gottlieb is more explicit on this point in the following passage (Plate 4).

> The role of the artist, of course, has always been that of image-maker. Different things required different images. Today when our aspirations have been reduced to a desperate attempt to escape from evil, and times are out of joint, our obsessive, subterreanean and pictographic images are the expression of the neurosis which is our reality. To my mind certain so-called abstraction is not abstraction at all. On the contrary, it is the realism of our time.[34]

The procedure through which this content is objectified, then, is not automatism in any pure sense of the word. It rather becomes a reciprocal relation engaged in between the artist and the momentary state of the object (although knowledge of the concept of automatism was essential to the Abstract Expressionists), and, at least in the early stages of the movement, best described by the artist himself.

> When I am 'in' my painting, I'm not aware of what I'm doing. It is only after sort of a 'getting acquainted' period that I see what I have been about. I have no fears about making changes, destroying the image, etc., because the painting has a life of its own. I try to let it come through. It is only when I lose contact with the painting that the result is a mess.[35] (Plate 2)

Rothko elaborates a similar idea in the following, and contemporaneous, passage.

Plate 4
Adolph Gottlieb, "Voyager's Return," 1946
37-7/8" x 29-7/8", oil on canvas
Collection of The Museum of Modern Art, New York
Gift of Mr. and Mrs. Roy R. Neuberger

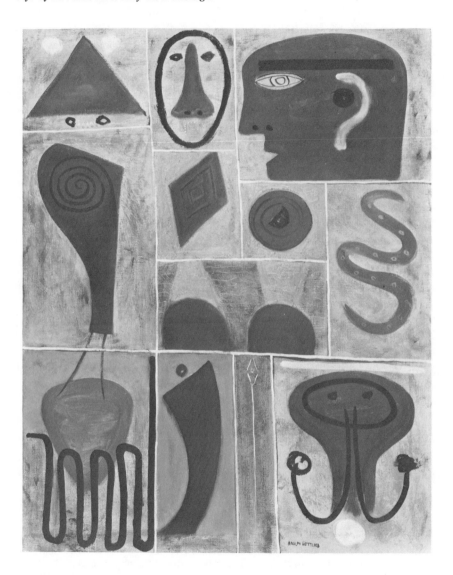

Neither the action or the actors (i.e., shapes) can be anticipated, or described in advance. They begin as an unknown adventure in an unknown space. It is at the moment of completion that in a flash of recognition they seem to have the quality and function which was intended. Ideas and plans that existed in the mind at the start were simply the doorway through which one left the world in which they occur.[36] (Plate 5)

Hans Hofmann, certainly one of the strongest links between European modernism and the new American painting, provides a possible link between these artists' ideas and tradition. His presence in the United States since 1933 and the vast influence he seems to have exerted as a teacher left almost no major painter, or even critic, unindebted.[37]

In 1948, on the occasion of a large retrospective exhibition, Hofmann had the following to say.

The significance of a work of art is determined then by the quality of its growth.

Thus, an idea is communicable only when the surreal is converted into material terms. The artist's technical problem is how to transform the material with which he works back into the sphere of the spirit.[38]

Barnett Newman was also influential as a theoretician, and less concerned with formal properties of a work than with its psychological content. His statements from The Tiger's Eye are representative of a group Sandler has called the myth-makers, and which included, at one time or another, most of the first-generation Abstract-Expressionists. The most notable examples of this trend were Rothko, Gottlieb, Still, and, of course, Newman himself. Although there is nothing very new in these ideas, the very fact that archaizing of this sort existed is significant (Baziotes and Stamos seemed to be more directly implicated in surrealist ideas while Pollock finds his closest analogues in Picasso). The "myth-makers" express more interest in artistic first causes than in the specific forms of early and primitive art exhibited in, for example, Pollock's mythical paintings of the late thirties and early forties. According to Newman, ". . . if we knew what original man was, we could declare what today's man is not."[39] Like most American painters, Newman is still concerned over the aesthetic, as was Motherwell in his appraisal of Surrealism. In Newman's article, however, the aesthetic is more concerned with creativity than with form.

Man's first expression, like his first dream, was an aesthetic one. Speech was a poetic outcry rather than a demand for communication.[40]

In our ability to live the life of a creator can be found the meaning of the fallow man. It was a fall from the good, rather than from the abundant life. And it is precisely here that the artist today is striving for a closer approach to the truth concerning original man than can be claimed by the paleontologist, for it is the poet

and the artist who are concerned with the function of original man and who are trying to arrive at this creative state.[41]

Sources for this kind of thinking are numerous and appear continuously from the end of the eighteenth century. Even in America, interest in primitive and Pre-Columbian art was well entrenched by the thirties, both as objects of collecting and as objects of artistic lessons. The most conspicuous examples among the Abstract Expressionists include the collecting activities of Rothko and the exhibitions mounted by Newman in the mid-forties. Finally, the interest of the Surrealists in primitive art must have carried much authority, and dated from as early as the *Minotaure* and to as recently as Paalen's *Dyn.*[42] Since Paalen probably met Gottlieb and Rothko in New York in the early forties, it is worth examining Paalen's introduction to his Amerindian Number at length.[43]

> Man begins where art begins, with the faculty of holding life in suspense, now to reflect, now to project the world; for the painted image precedes writing as the imagination precedes thought, or rather; the imagination surrounds thought in every sense, thought being no more than the focal point of present consciousness. That is why, as inherent in the very sub-structure of all distinctively human activity, art can reunite us with our prehistoric past and thus only certain carved and painted images enable us to grasp the memories of unfathomable ages. So, too, in the direction of the future—as it is only through the imagination that thought can find its aim—it is art that often prefigures what might be. . .

> Such an effort at integration prefigures nothing less than a vision that today only the most audacious dare to entertain: the abolition of the barriers that separate man from his own best faculties, . . . To a science already universal but by definition incapable of doing justice to our emotional needs, there must be added as its complement, a universal art . . .[44]

The conservatism of the artist's statements finds a parallel in the "little magazines" which accompanied the new movement in American painting, *The Tiger's Eye* and *Possibilities*. Nominally functioning as the official publications of the avant-garde, neither of these were capable of producing even novel reports on the contemporary painting scene. The causes of this conservatism stem from the general decline of an avant-garde spirit in America, the lack of a tradition in art criticism, and obtuse editorial policy. Ruth Stephan, editor of *The Tiger's Eye*, who, according to Parker Tyler, takes her cue from James Laughin's *New Directions* editorial policy, is quoted as saying the following.

> It is our intention to keep separate art and the critic as two individuals who, by coincidence, are interested in the same thing, and any text on art will be handled as literature.[45]

Plate 5
Mark Rothko, "Vessels of Magic," 1946
38-3/4" x 25-3/4", watercolor
Courtesy of The Brooklyn Museum of Art

Although *Possibilities* had a more liberal editorial policy there was little that could be called new. In the words of Parker Tyler, *"Possibilities* and *The Tiger's Eye* strike a significant keynote in the little magazine history. That keynote is moderation in advance-garde aims."[46] Even Rosenberg's contributions to *Possibilities,* if they were not viewed in relation to his other writing (and therefore retrospectively), would have considerably less polemical value than they now seem to have. Even in 1948 Tyler saw that what was lacking was a sense of direction.

> The 'extremism' as well as the 'possibility' referred to in the *Possibilities* editorial evidently are scheduled to substitute for school or style tendency in the arts, but such terms (without the art/politics issue) merely underline the strict experimental character . . . One misses a pervasive atmosphere in *Possibilities* that must exist to convince a reader that a magazine is present a l'avant-garde. . . . Above all, in no recent arrival in the little magazine field is there any directional energy, any organization of ideas, any real novelty, any group inspiration. . . . The golden tradition of the advanced guard is simply this: Wishing to transform the whole domain of the arts, it addresses itself primarily to the artist, the producer, not to the audience, the consumer. Therefore, it must be favoritist; it must be full of internal combustion. Otherwise it is simply luxury merchandise in esthetics.[47]

To lay this lack of "directional energy" at the feet of the critics, however would be a mistake. Indeed, in the next chapter, I hope to show that it was precisely this lack of energy that the progressive critics, notably Rosenberg and Greenberg, were trying to meet.

The Philosophy and Function of Criticism

Just as the critical literature divided on points of meaning and the nature of its historical sources, it also separated according to what any particular author believed to be the function of criticism. It is self-evident that artists and critics could divide along these lines, but it is equally true that among the critics themselves little agreement could be reached on what this function was—or whether it could vary with different historical circumstances.

Joseph Margolis has offered a classic definition of criticism (and implicitly a description of its function) as ". . . an effort to clarify the aesthetic design of some particular work of art"—in a broad sense, an interpretation. He also states the criteria which determine the plausibility of interpretive statements:

> And just as an hypothesis about the origins of the solar system must accord with the known laws and facts of the system, would-be interpretations must accord with the description of a given work and with the admissible 'myths' or schemes of imagination.[1]

Such a point of view recalls Greenberg's notion that they [works of criticism] must be "in accord with the most advanced view of the world obtaining at the time." What makes a myth admissible, for Margolis, is whether or not it works, which in turn depends upon the condition that ". . . it is so much a part of our general culture that the imagintion of both artists and of semi-educated persons is saturated with it."[2]

> . . . schema of the imagination which, independent of the scientific status of the propositions they may subtend, is capable of effectively organizing our way of viewing portions of the external world in accord with its distinctions.[3]

> We think, see, and imagine in terms of Freudian symbols, not merely because our subconscious selves employ them for ulterior ends—a debatable thesis in the science of psychology, but because our conscious selves have assimilated the fascinating perspective and fictions that Freud invented.[4]

A slightly less catholic interpretation of the critic's role is provided by Robert Goldwater who, nevertheless, approaches many of the same conclusions. One of these is the provisionality of the content of criticism on the objects it

seeks to discuss. Thus, for Goldwater, criticism should ". . . change, not its basic methods, but its emphases as the art with which it deals changes, taking its cue from the total context at hand."[5] This is true for Goldwater even in the verification of the artist's intention; ". . . it is still only from within this work that such insights can be sustained. The intention has not been executed; the intention as we may know it from elsewhere corroborates, or perhaps does not, the work as perceived."[6] Art is convincing to Goldwater only to the extent that it remains a plastic language.[7] For Goldwater, recent criticism has failed by confusing two distinct "subjects of study: art and the process of creation."

> The examination of the latter is often taken for the study and criticism of the former. Such a danger inheres in the evaluation of any art of romantic inclination: criticism then follows the same bent. The tendency was increased by the popularly held view of Abstract Expressionism which defined it as a record of process, i.e., of the stages of the process of an exteriorization of emotion. And it was further intensified by the application of simplistic psychological formulations concerning the mechanisms of creation. Despite the lapses of time and of styles, it is still much in vogue. Yet art, and the psychology of artists, although related, remain two distinct subjects.[8]

Critics have evolved certain expectations about the relationship of art and criticism from discussions like these. To the extent that these relationships do not evolve in "real" situations, at least to the critic holding this position, criticism has failed. While Goldwater's article may represent an ideal notion of how criticism should work, I feel it is hopelessly inadequate as an instrument for describing how criticism *did* work. Its inadequacy involves not only describing how criticism of art actually proceeded but also how it functioned; that is, not only as regards the content of the criticism, but also in locating the motives of the critics. If the philosophy of criticism is incapable of accounting for the historical functions and motives of critics, I believe we may fairly suspect it is also incapable of describing the historical relation of criticism to the art it purports to discuss. By disqualifying Goldwater's philosophical model as potential historical explicandum it is hoped that the "real," in contrast to the declared, relationships of art to recent criticism will become clearer.

One of the biggest problems in sustaining Goldwater's point of view involves the collectively based motives of abstract-expressionist statements (this is particularly true of the early literature). Goldwater's insistence on verification of criticism in the work of art makes it difficult for the critic to talk across the works of various artists. That "talking across" was a goal of the early critics can hardly be disputed. Accompanying a desire to "market" certain artists was the critic's intention to encourage a new vitality across the whole scene of contemporary art. It was precisely this concern which provoked Rosenberg's analysis of the creative process and Greenberg's philosophy of

history. It is understandable that these two points of view would find their application in individual painters somewhat unevenly, a matter that will be discussed in more detail later in the chapter.

In respect to this collectively based criticism, it is important to point out once again that the "community" of Abstract Expressionists was not founded on shared traits in the respective artists' works, but more on behavioral norms and on the common enemies of conservative taste and criticism. It should come as no surprise, then, if criticism of the type mentioned above did not beg verification in specific works of art. It is safe to say that criticism of this type bore few if any important relationships to the work of art. This does not mean that such criticism might not be "art" criticism (as Goldwater might suggest). What it does mean, however, is that Goldwater's rejection of abstract expressionist criticism as "confused," judged in terms of the criteria of classical art criticism, is pointless. In fact, it only serves to obscure the real function abstract expressionist criticism did perform. Since this book is concerned with the "Critics of Abstract Expressionism," a movement no one is certain ever existed, especially in formal terms, the above considerations assume great importance. It is no accident that the criticism Goldwater described came into its own only when the New York "community" (real or imagined) had been established and accepted in the early- to mid-fifties. The result of ignoring this community function of criticism has permitted such hopelessly unhistorical appraisals of the critics of the forties and fifties as the following by B.H. Friedman.

> I see no qualitative difference between an uninformed viewer saying 'All modern art looks alike,' and a critic lumping together (except geographically or chrono-logically) such very different artists as, say, Pollock and de Kooning.[9]

Friedman's statement is reminiscent of Cendrars' late proclamation on Cubism that "One can already foresee the approaching day when the term Cubism will have no more than a nominative value to designate in the history of painting certain researches carried out by painters between 1907-14."[10] This statement was, of course, issued after the experimental years and addressed Cubism's survival after the war when the need of a program was less keenly felt. By contrast, Leonce Rosenberg, a dealer who assumed the role of the movement's chief sponsor after Kahnweiler, encouraged newcomers and devised a late stage of theory quite at odds with Cendrars' skepticism.[11] The basis of Friedman's or Cendrars' complaint over avant-garde criticism was effectively analyzed by Poggioli.

> Unfortunately, avant-garde criticism, instead of working autonomously alongside avant-garde art, has too often let itself be determined, in both the negative and positive way, by the avant-garde spirit. That spirit has historically conditioned

criticism in a more decisive manner than has avant-garde art, if not by necessity, then by contingency. Critical judgment, in other words, instead of tending toward a conscious reconstruction of the ambiance of the works or toward an intelligent interpretation thereof, has preferred to develop the subordinate task of controversy and polemic, for propaganda for or against.[12]

To understand both the character and necessity of this community directed criticism in the forties it is important to recall what features of the American scene prompted this desire for a community in the first place.

The American artist was in the uncomfortable position of being a provincial in an age when being a progressive was the whole point in European art (this notwithstanding post World War I conservatism in certain European artists). Even in their best moments, American artists and critics viewed themselves as "provincial progressives." With the demise of Paris in the late thirties, and encouraged by the emigration to America of artists from war-torn Europe, Americans found their chance to erect a truly progressive (in the sense of leading) metropolitan center. But the American tradition, because of its paradoxical historical position, was of little use. One does not start a progressive community from a position already well behind the times. It was natural that two critical extremes (in the works of Greenberg and Rosenberg) suggested themselves to Americans who were partially unwilling, partially unable, to "continue" the European scene where it had left off. This, it should be remarked, is no contradiction of the fact that both Rosenberg and Greenberg depended heavily on European traditions in art and criticism.

When the critic went into the actual studios, however, what greeted him was a vast confusion of styles and little, if any, continuity. A look at various exhibitions throughout the forties and early fifties consistently yields such breadth that it is little wonder community lines were difficult to establish through shared traits in the works. That a catalogue as recent as Tuchman's (1965) does not submit to this either, even though much of work present on the earlier scene was omitted by this time, only underscores the implausibility of critics doing it in the fifties.[13]

The University of Illinois exhibitions "Contemporary American Painting and Sculpture" exhibit this breadth in a rather extreme fashion. The conservatism of the committee is implicit in the following excerpt from the 1948 catalogue.

Many of the visitors to the show or those looking through the illustrations in this catalogue, will find some examples which puzzle or displease them. On the other hand, anyone—should find paintings in the exhibit which accord with his established ideas.[14]

Probably the single outstanding fact about this exhibit is that there is not a single "new" looking painting included. But more important for the present purposes is the presence of work which continues to reappear in New York group shows through the early fifties. Besides Guston, Gottlieb and Hofmann (all represented by older paintings), work of Levi, Byron Brown, Karl Knaths, and I. Rice-Pereira may serve as examples.

By 1951 Illinois had included some work of most emerging artists on the New York scene (Gottlieb, Tomlin, Baziotes, Pollock, Rothko, Pousette-Dart, Motherwell), but maintained what today we view as the more conservative work of Kurt Roesch, Jean Xceron, Lorser Feitelson, and the Surrealists Ernst and Seligmann.[15] Much the same could be said of the 1955 show, except that the first generation had somewhat lost place to younger artists such as Edward Corbett, Richard Diebenkorn and James Brooks.[16]

The Museum of Modern Art exhibitions of American painting, edited by Dorothy Miller, show approximately the same trends. In *Fourteen Americans* (1946)[17] Gorky, Motherwell, and Tobey are included with I. Rice-Pereira, Saul Steinberg, Honore Sharrer and other conservative artists. By 1952,[18] the inclusion of Rothko, Still, Tomlin, Pollock, Baziotes and Ferber shows, as does the Illinois exhibition of 1951, that the method of selection that generally governs retrospectives in the late fifties and sixties was already underway. The inclusion of figurative work in the show, particularly that of Kiresberg and Katzman, only emphasizes the new hegemony of the "ordained" Abstract Expressionists.

I am not suggesting that what I have characterized here as conservative artists were unimportant or uninfluential. On the contrary, I wish to emphasize that through the early fifties they occupied a prominent place in exhibitions. It was only in the last decade that they were written out of the history of "progressive" American art.

The cross-section maintained in New York group exhibitions appears just as convincingly in *Modern Artists in America*[19] and the "salon" exhibition held at the Stable Gallery in February 1954.[20] The editors of the former publication introduced their plates with the following remarks.

> The collecting of these illustrations was begun by us in 1949, at the start of the 57th Street exhibition season; and they are in the main restricted to 1949-50. Since then the scene continues to change, with the modern aspect better, if haphazardly reported. Thus though this volume bears the mark of its date in a few respects, it is valued for its orderly documentation and completeness. And since what is continually needed is a systematic and sympathetic treatment of our chosen area avant-garde art in America, we intend to document similarly the seasons of 1950-51 and 1951-52.[21]

All the presently touted Abstract Expressionists were well represented, but the broad variety of styles is still present (which in the present context may be less surprising since the work was selected by painters). Burgoyne Diller, Harry

Holtzman, Ilya Bolotowsky, Fritz Glarner, Joseph Albers, G.L.K. Morris and Jean Xceron are representative of the purist camp of abstraction, while Kay Sage, Stanley Hayter, Yves Tanguy, Kurt Seligmann, Wilfredo Lam and other thorough-going Surrealists are present as well. There is also a considerable group of loose abstractionists which include George Cavallon, Karl Knaths, Carl Holty, Harry Bowden and others.

The complexity and richness of exhibition trends in New York, and their relations to avant-garde criticism, recall a similar development earlier in the century. Addressing a similarly complex pictorial development, the critics of the cubist painters did not confine themselves to "classical" criticism. According to Golding, Apollinaire "found it hard to identify many specific characteristics shared by the painters, or even to distinguish Cubism from Fauvism."[22] Typical of avant-gardism, Cubism rejected the idea of its being very systematic for fear of being viewed as an academy.

> The new painters who made manifest this year, at the 'Salon des Artistes Independants' of Paris, their artistic ideals, accept the name of Cubists which has been given to them. Nevertheless Cubism is not a system, and the differences which characterize not only the talent but the styles of these artists, are an obvious proof of it.[23]

This view is echoed by Hourcade who claims that "the main interest of Cubism is the total difference of the painters from each other," and that what they had in common was their rejection of Impressionism.[24]

This did not mean that they were disinterested in community ties of any sort. Curiously enough, the program Apollinaire mounted for the Cubists resembles Greenberg's in many respects, particularly in his idea that art was "progressing" toward some new stage of purity.

> The secret ambition of the young painters of advanced tendencies is to create a form of pure painting. This is a completely new kind of plastic expression. It is still in its infancy and not as abstract as it aspires to be.[25]

Apollinaire particularly admired Delaunay whose works most approach pure painting, and his use of the analogy with music was later exploited by Greenberg.

> Thus we are progressing towards an intensely new kind of art, which will be to painting what one had hitherto imagined music was to pure literature.[26]

Apollinaire, like Greenberg and others, mounted a criticism relatively unconcerned with attributes in the work. This is not only possible, but predictable, says Poggioli, who, in the following quote, brilliantly characterizes what all avant-garde critics seem to have in common.

If we concede that the task of an elect public is not to formulate a permanently valid critical judgment, but to welcome sympathetically a given revolution in taste, the necessary and sufficient condition for membership in the elite would be an intuition of the historical mission of avant-garde art (more important than any evolution of its specific contributions or even any understanding of the esthetic meaning of its message). Also in the practical area, we must recognize that one need not understand each of the individual or collective manifestations in which that art unfolds in time and space.[27]

If it is true that the critics were motivated by their desire for a community, and that their criticism often has little to do with the individual objects or even painters, this should be apparent from their treatment of any specific artist's work. I would like to suggest that the critical models of both Greenberg and Rosenberg are used as measures of the historical position of art rather than as tools for revealing what is in the art. Gorky is an obvious choice for testing this kind of assumption, since he was both very important for other artists of the mid-forties and since his art was somewhat uncongenial to either of the critics' theses. For each critic, Gorky becomes as good or important as he is amenable to their respective criticisms.

Each critic had an idea of what important art should be and proceeded to encourage a community of interests, not necessarily pictorial, surrounding these ideas. If this is the case, the question remains for some *why* critics encouraged such community interests—*why* they disallow any change in their critical standards. One view, especially concerned over Greenberg's role of artistic prophet in the sixties, has suggested that the critics were attempting to make their literature a self-fulfilling mechanism geared to intellectual aggrandizement. Others have seen politics as the motivating factor. I have tried to suggest above that it need be neither politics nor the prospect of fame that prompted this writing, but, rather, the need to present what at least appeared to be a united front to the establishment. An avant-garde needs a rallying point, and as Rosenberg and Greenberg were both keenly aware, it was by conferring on Abstract Expressionism the status of the avant-garde that they could best authenticate the modernism of the movement.

Gorky's first one-man show was held in 1945 at the gallery of Julien Levy, who was then the major surrealist dealer in New York. The catalogue of the show as written by André Breton, who unabashedly claimed Gorky for his group. "Gorky is, of all the surrealist artists, the only one who maintains direct contact with nature."[28] According to Elaine de Kooning, Gorky himself was quite pleased over his identification with the Surrealists, and his ties with the group were strengthened by his close association with Matta. Concerning Gorky's pictures, Breton has the following things to say (Plate 6).

Here for the first time nature is treated as a cryptogram. The artist has a code by reason of his own sensitive anterior impressions, and can decode nature to reveal the very rhythm of life.[29]

Equally Surrealist is Breton's definition of Gorky's "hybrid" forms.

> By 'hybrids' I mean the resultants provoked in an observer contemplating a natural
> spectacle with extreme concentration, the resultants being a combination of the
> spectacle and a flux of childhood and other memories.[30]

Viewed against Breton's forward, Greenberg's review of the same exhibi-
tion seems strongly inhibited. Although Greenberg recognizes Gorky's skill as
a painter, his importance as an artist is questioned.

> He became one of those artists who awaken perpetual hope, the fulfillment of which
> is indefinitely postponed. Because Gorky remained so long a promising painter, the
> suspicion arose that he lacked independence and masculinity of character.[31]

Had he taken the right direction, declared Greenberg, he could have been a
major talent. Greenberg, however, was fully aware of his surrealist affiliations—
affiliations which, to his mind, did not provide the makings of a new art.

> This new turn does not of itself make Gorky's painting necessarily better or worse.
> But coming at this moment in the development of painting, it does make his work
> less serious and less powerful and emphasizes the dependent nature of his inspira-
> tion.[32]

Greenberg's linear history of art is so rigid, and his dedication to the Cubists so
great, that he tells us "the problems of biomorphism were never really problems
for modern painting."[33] The only work in the exhibition which promises
something in the future is "They Will Take My Island," a work which "indi-
cates a partial return to serious painting and shows Gorky for the first time as
almost completely original."[34]
 A year later, although Greenberg is much more generous with Gorky,
the question of what the artist will *become* still looms largest. "Gorky's art does
not yet constitute an eruption into the mainstream of contemporary painting,
as I think Jackson Pollock's does."[35] This is a rather interesting statement since
it puts the work of Pollock into the mainstream—the mainstream apparently
being the mainstream of the avant-garde. In any case, Greenberg suggested what
was needed to put Gorky into this mainstream.

> Yet the chances are . . . that Gorky will soon acquire the integral arrogance that his
> talent entitles him to. When he does acquire that kind of arrogance, it is possible that
> he will begin to paint pictures so original that they will look ugly at first.[36]

The inconsistency of this statement with an art Greenberg himself described as
"lyrical," "personal," "elegant" and "felicitous" is obvious. That Greenberg very
much liked Gorky's work turned out not to be the central issue for him.

Plate 6
Arshile Gorky, "The Liver is the Cock's Comb," 1944
72" x 98", oil on canvas
Albright-Knox Art Gallery, Buffalo, New York
Gift of Seymour H. Knox, 1956

Harold Rosenberg, even with the advantage of a decade's hindsight, remained as committed to his critical system as Greenberg earlier had to his. If Rosenberg's criticism seemed to fit Gorky's art better than Greenberg's, it is not so much his concern over the art itself as it is the similarity of his own and Gorky's sources. Rosenberg believed that modern art had progressed from other art, but that "the fall of the city [Paris] to the Nazis closed off finally the source from which art could hope to continue to feed on art."[37] This was true no less for the American provincial than for the European painters.

> The bankruptcy of a rationale of progress in regard both to art and to social history had to be acknowledged and an appeal addressed to other powers of the mind.[38]

It was the presence of the Surrealists in America and their "grasp of the consciousness through immediate experience" that allowed Gorky, as an individual, to break out of his artistic stalemate.[39]

Like Greenberg, Rosenberg claimed that "the problem of the artist had become a total one; no longer to explore a law of nature but to qualify as the vehicle of the evolution of art."[40] Yet the content of Rosenberg's rationale was quite different, and, unlike Greenberg, who thought Gorky was good but not important, Rosenberg viewed Gorky as a great innovator.

> Yet Gorky was a pioneer in discovering the primary principles of America's new abstract art For him, as for the Action Painters, the canvas was not a surface upon which to present an image, but a 'mind' through which the artist discovers by means of manual and mental hypotheses, signs of what he is or might be.[41]

Illustrated works receive little or no discussion from Rosenberg.

The point in discussing Gorky, of course, has not been to decide who was right—Greenberg, Rosenberg or Breton—but merely to observe that the fate of the artist in the hands of these critics was predictable. The critic's task became more to postulate what Rosenberg called a "rationale of progress" than to set out the virtues of any specific paintings or painters.

The Consolidation of Abstract Expressionism in the Fifties

Greenberg's appraisal of the gallery situation in 1949 indicates his anxiety over the plight of the progressive New York artists and the extent of the difficulties they found themselves in. He detects less activity in the New York scene since the previous 1947-48 season, the year of florescence among the "little magazines " Concerning the 1947-48 season, Greenberg has the following to say.

> It was as if a new current of critical as well as creative activity had emerged, almost suddenly, to raise the collective level of our advanced art to a point of awareness and performance beyond anything it had known before.[1]

Speaking then of the 1949 season, Greenberg continues.

> I do not think by any means that this current is now exhausted; certainly if a year were enough to do that, it could hardly have the character I claim for it. But it may be subject to ebb and flow, and after its first rising it may have had to contract itself the better to assure and consolidate its reality.[2]

Greenberg here implies the existence of a community, and his reference to its "consolidation" at mid-century accurately locates a major shift in emphasis detectable in the early fifties. Over the experimental stage, to a large extent, both artists and critics alike were interested in making inventory of and reinforcing their gains. For the artist, and even the critic to an extent, this meant finding an increased market for his work. Although Kootz, Parsons, Egan, Janis and others did promote the new art, Greenberg rightly remarks that "They play a role disproportionate to their number, their financial strength, and the amount of work they circulate."[3] As for the prestige galleries (Matisse, Buchholtz, Rosenberg), they

> . . . do in general show inhospitality toward almost everything new or adventurous in the latest American art. Good business may justify this policy, but the firms in question cannot boast that they act with full responsibility toward art.[4]

There can be little question, in view of these circumstances, that a major function of criticism at this point was to encourage a functioning artistic

community; and, if this is true, the polemical character of much of the literature is not only understandable, but functionally required.

This anxiety over establishing a community identity, particularly in view of a strong European bias among the galleries, was naturally aggravated by the indifferent reception given American work by the European critics. The following exchange, between Greenberg and David Sylvester, concerns the American pavilion at the 1950 Biennale in Venice.

> . . . I gather that the treament our painters got at the hands of European critics was at best condescending at worst indifferent or impatient. [Aline Louchheim] The first, she says, is the 'habit of Europeans to think of Americans as cultural barbarians'; the second, their resentment of their present military and economic dependence upon us.

> Sight unseen, I tend to agree with Mrs. Louchheim. Still, this does not prevent me from being taken aback when Douglas Cooper of England dismisses John Marin as 'convulsive and somewhat inept' and Jackson Pollock as 'merely silly' (I cull these words from Alfred Frankfurter's column in the September *Art News*). Nor was I any less taken aback by the remarks of another British critic, David Sylvester, which *The Nation* published in these pages on September 9. What surprises me, however, in both cases is not the prejudice but the signs of a lack of critical competence.[5]

Mr. Sylvester's reply is typical, and, from his point of view, no doubt justified.

> Ignazio Silone has said that the trouble with Communists is that they can never believe that any criticism of them is made in good faith.[6]

Relying on the authority of the modern tradition in Europe, Sylvester believes that the American work is neither especially new nor especially good.

> I disliked it because most of it represented a brand of American Romanticism which, whether its outlet is painting, literature, or the theater, I find repellent and contemptible because it is incoherent, modernistic, mucoid, earnest, and onanistic, because it gets hot and bothered over nothing and reminds me of Stieg's drawing called 'I can't express it.'[7]

Even at this early date, Sylvester finds Greenberg's strict notion of what constitutes the "modern" a confining one; that is, the "Cubist order which he believes is 'the only order possible to ambitious painting of our time.' "[8]

> Is Mr. Greenberg prophet or dictator?—or does he intend to do all the ambitious painting himself? If not, how the hell does he know so much?[9]

Six years later Patrick Heron, another English critic, expressed the following sentiments on American painting. The occasion was the Museum of Modern

Art's exhibition, "Modern Art in the United States."

> Whatever I have said, I would like to end by insisting that to me and to those English painters with whom I associate, your new school comes as the most vigorous movement we have seen since the war. If we feel that far more is suggested than is achieved, that in itself is a remarkable achievement. We shall now watch New York as eagerly as Paris for new developments . . . and may it come as a consolidation rather than a further exploration.[10]

The Americans themselves seemed less anxious over the question by 1953 when a symposium was held specifically to ask the question, "Is the French Avant-garde Overrated?" Ralston Crawford is typical in thinking that Americans have made too much of the question.

> 'There haven't been any great artists in Europe since Picasso,' has become an American song. Then there is the unsung, but often suggested chorus: 'That makes us all great.' The logic leading to this chorus has eluded me for a long time.[11]

Motherwell reflects the same sort of attitude.

> The questions don't seem very actual to me. Only one painter I know seems to be preoccupied, and he less than before, with French rivals. On my part, painting is not a competition. . . . Who is 'French' and 'American' anyhow?[12]

Of the participants, only Greenberg expresses much interest in the question, and I believe we may interpret even his remarks as a point of critical honor.

> Do I mean that the new American abstract painting is superior on the whole to the French? I do. Every fresh and productive impulse in painting since Manet, and perhaps before, has repudiated received notions of finish and unity, and manhandled into art what seemed until then too intractable, too raw and accidental, to be brought within the scope of esthetic purpose.[13]

How cavalier Americans had become over their position in the tradition of modernism is suggested by the magazine's inclusion of a ballot which invited the public to share in the fun.

It was not only the galleries which ignored the artists in the early stages, but the more "official" organs of the art world as well. For American artists in the forties and early fifties, this meant the Museum of Modern Art. As a protest against what they viewed as unbecoming conservatism, prominent members among the new artists picketed the Museum in May of 1948. This action followed the example of Boston artists who were angered by the statement of James S. Plaut, director of the Institute of Modern Art in Boston, that the "Modern" in the title should be changed to "Contemporary" since "modern" art was anathema to the public.[14]

Somewhat later, a group named the "Irascibles" penned a letter to Roland L. Redmond, president of the Metropolitan Museum, which protested the conservatism of the juries (both regional and awards) composed for the upcoming national competition to open at the Metropolitan in December of 1950.[15] The following is excerpted from the letter, which appeared in an *Art News* editorial by Alfred Frankfurter, and which included the names of the painters and sculptors who supported it.[16]

> The under-signed painters rejected the monster national exhibition to be held at the Metropolitan Museum of Art next December, and will not submit work to its jury.
>
> The organization of the exhibition and the choice of the jurors by Francis Henry Taylor and Robert Beverly Hale, the Metropolitan's Director and Associate Curator of American Art, does not warrant any hope that a just proportion of advanced art will be included.
>
> We draw to the attention of those gentlemen the historical fact that, for roughly a hundred years only advanced art has made any consequential contribution to civilization.
>
> Mr. Taylor on more than one occasion has publicly declared his contempt for modernist painting; Mr. Hale, in accepting a jury notoriously hostile to advanced art, takes his place beside Mr. Taylor.
>
> We believe that all the advanced artists of American will join us in our stand.

What issued from all this dissatisfaction was a new and self-conscious effort at consolidation. One of its first expressions was the publication of *Modern Artists in America* (Reinhardt and Motherwell, eds.) in which a documentation of the entire movement to that date was attempted.[17] Characteristic of this publication was a deliberate and objective willingness to let the art speak for itself—an attitude not generally found in the earlier writings of the critics. Nevertheless, there is little discussion of the works in formal terms. The contents include an edited version of the "Artists' Sessions at Studio 35"[18] and the "Western Roundtable of Modern Art,"[19] edited by Douglas MacAgy, both of which were more concerned with the sociology of contemporary art than with its aesthetics. Topics covered at the roundtable included "The Cultural Setting," "Art and the Artist," "The Critic," "The Collector," and "The Museum." Although the discussions often seem marginal in the context of Abstract Expressionism, many of the same concerns came up in the "Artists' Sessions at Studio 35."

The list of plates, intended to document the American avant-garde, is prefaced by a group of pictures which presumably represent its parentage, or aspects of it, and, finally, a few additional pictures of "Advanced French Art." The

question of French or American leadership is not overlooked by the editors who include an essay called "Paris-New York 1951" by Michel Seuphor.[20]

In the only statement of an editorial nature, the editors remark, rather surprisingly from the point of view of this thesis, that ". . . it is odd that this effort to bring some order into the situation should come not from critics or scholars, but from practicing artists; still, this may have its good side."[21] I hope to show, in another context, that Motherwell and Reinhardt misunderstood both their own task and that of the leading avant-garde critics.

Another step toward this consolidation was the Ninth Street Exhibition (1951) and succeeding "Salons" which the artists themselves organized and mounted with some outside help from Leo Castelli. In the spring of 1951, agreement was reached to hold the exhibition, and the show was installed in an empty store at 60 East Ninth Street. Contrary to all expectations, it attracted a good deal of attention. The Salon, as Hess has pointed out, is "by, of, and mainly for artists," and it is here that one would expect to find some expression of communal interests. Hess, sensing the difficulties of expressing the terms of such a community, had the following to say about it.

> The very amorphousness of the process of organizing the Stable exhibition suggests a further quality. A few artists decided that the exhibition of the past two years should be repeated. They picked a group of about twenty-five others which, in turn, met to invite the remaining hundred and twenty-five. The ability of the selecting group to act as a collective conscience was never questioned, nor was there any difficulty in picking it. Who would have thought the collective soul was worn so openly on the sleeve.[22]

> And the basic standard is the individual's sensitivity to and sympathy with this collective aspect of present moment.[23]

Further, and even earlier, expressions of the community of which Hess spoke are not hard to find. Among its formalized expressions can be included the Subjects of the Artists School (1948-49), Studio 35 (1949-sp. 1950), and the "Club" (fall 1949 through the fifties). Its informal expressions centered around the Waldorf Cafeteria and Cedar Street Tavern. Sandler has pointed out, significantly, I believe, that few ideas were actually *generated* through these agencies.[24] Their importance seemed to lie, instead, in the fact that this is where (besides in the studios) the artists, critics, collectors, etc. behaved with each other—a situation providing what Quine might characterize as the matrix through which "meaning" for his work was acquired for each individual. The critics were not without their own, and rather considerable, debt to these socializing aspects of the New York scene.

> Of all the subjects discussed, the one that recurred most often and that created the hottest controversy was the problem of community, of defining shared ideas,

interests and inclinations. Much as the Abstract Expressionists hated the thought of a collective style, its possible existence concerned them. . . . The issue of group identity was also raised at the Studio 35 sessions in April, 1950. Gottlieb said, 'I think, despite any individual differences, there is a basis of getting together on mutual respect and the feeling that painters here are not academic. . . .' Newman picked up this point, 'Do we artists really have a community? If so, what makes it a community?' This question was central to the symposiums on Abstract Expressionism (Pavia called it 'The Unwanted Title') at the Club in 1952.

Part of the difficulty in defining and clarifying shared ideas was the verbal style of the Club. Artists refused to begin with formal analysis, pictorial facts or the look of works. This approach might have implied that Abstract Expressionism was a fixed and established style whose attributes could be identified. Further, the idea of style assumed that making a certain kind of picture was a primary aim. This, the Abstract Expressionists denied. Indeed, most adopted an unpremeditated method to avoid style. The problem of how and why an artist involved himself in painting was more exciting to them than the mechanics of picture-making. [25]

Contemporary with these events and, perhaps most influential in finally legitimizing the movement, was the publication of *Abstract Painting: Background and American Phase* by Thomas B. Hess in 1951,[26] and the Museum of Modern Art's exhibition of the same year, *Abstract Painting and Sculpture in America.*[27] Organized by Andrew Carduff Ritchie, the latter exhibition went far in conferring "official" sanction to the movement.

Hess was the first author to treat Abstract Expressionism as the main subject of a book-length publication. Although not terribly influential on later criticism, Hess was a case of good entrance, and for several reasons. First, he was well known and had a wide readership through his position as editor of *Art News.* Secondly, his lack of concern over his critical apparatus must have alienated fewer people than the more tightly knitted and more demanding designs of either Greenberg or Rosenberg. Composed more of spectator insights of a coloristic type, and organized loosely around the lives of the individual artists, Hess' criticism may be viewed as a transition from the early polemical criticism to that of the fifties, where the purpose seemed to be more in line with the intentions of classical criticism, that is, to provide a design for profitably viewing a work of art. Although the general tenor of his writing owes much to Rosenberg, there is little of the radicalism encountered in Rosenberg's "The American Action Painters" of 1952. Indeed, the first half of Hess' book is devoted to the movement's European parentage. Formalism finds its place (the book was written upon the suggestion of Clement Greenberg), although he ends the book by stating, ". . . there is no abstract art."[28] This is really no contradiction because what Hess means is that all *good* art is abstract in a certain sense.

Hess's notion that the new painting reflects its material environment, in precisely the sense that Rosenberg wishes to deny in *The Anxious Object,* most clearly separates him from other critics. "Painting, although a social act, is of,

not from the time—just as a tree is of the meadow, and though bent by the same wind, and growing in the same earth, sunlight, and water, still has its own roots and blossoms."[29] Unlike Greenberg, who was more interested in demonstrating the historical logic or inevitability of the movement, Hess was content to describe the possibilities inherent in European and American modern artistic cultures. In this respect, his cursory mention of Matta, Masson, and other influential figures of the forties is surprising. Equally surprising, and more unusual among American commentators, is the historical weight he gives to America's own directions in abstract art during the thirties and forties. The following quote describes a work by Arthur B. Carles, who indicates to Hess the point at which America assumed her leadership. "Action involves so many associations with form that each element retains its independence, but still invites associations."[30]

In terms of the temperaments of its artists, Hess identifies Abstract Expressionism most closely with the line of expressionism bridging Van Gogh and Soutine. It is also an extension of it, and to that degree, different from it.

> The crisis for Van Gogh and Soutine was to find a way to affirm the existence of secret anguish and ecstasy, but to do so as a creative artist; this, they felt demanded working in Paris' tradition of distinterested pictorial means As has been suggested, their solution was a passionate and totally sensitized identification of the subject with the creative act—emotion became realized in paint as it was objectified in nature.[31]

Hess believed that the tension in Soutine was finally resolved in the Abstract Expressionists. DeKooning's solution has been to make the crisis itself the hero of his art.[32]

> Furthermore, it is from his, DeKooning's, position that the picture evolves and not from any preordained set of constrictions, which is how he and many other of the new artists viewed the School of Paris.[33] (Plate 7)

Illustrations of what separates his writing from Greenberg's or Rosenberg's— what Pavia called his paint-stained vocabulary[34]—appear on every page, and his descriptions of de Kooning, who provides the fulcrum for all Hess' discussions of the new artists, are particularly eloquent.

I have already suggested that Hess' notion of crisis was less a philosophical or metaphysical problem than the simple notion that artists were wanting for comfortable material circumstances. This permits him to assess the mood of New York artists in quite a different, and as it were, more positive light than Rosenberg.

> . . . a cheerful optimism as far as the future is concerned, a self-reliant re-examination of the past, and an assertive enjoyment of the present is proclaimed in painters' conversations and gestures. There is a feeling of arrival, and an ability to cope with crises.[35]

Even though Hess claims that ". . . A park commissioner who loathes all contemporary culture with a cold, active fury, is an appropriate homologue of the New York Medici,"[36] he avoids the nihilism of Rosenberg, and expresses his pessimism almost as a dramatic afterthought.

Andrew Ritchie, director of the Painting and Sculpture Department in the Museum of Modern Art, also found non-revolutionary ways of incorporating the new art into traditional painting. But contrary to Hess, who thought there was something new to make sense out of, Ritchie has so generalized these artists into his categories that little appears to separate them as a group from tradition. The overriding fact about this exhibition is that examples of the new art were included.

In categorizing the work, Ritchie is inclined to put the "Abstract Expressionists" into what he calls the "Expressionist Biomorphic" group. He recognizes the early and important role of Gorky ". . . who looked mainly to the Surrealists inspiration of Miro and Picasso for [his] organic abstractions."[37]

> This whole anti-intellectual, expressionist school, like its earlier forebears Van Gogh, Gauguin, Kandinsky and others, appeared to express its evangelical disgust with a dislocated world of wars and depressions by a return to an emotionally inspired imagery and spatial dynamism, in an anarchistic effort to throw off the constrictions of worn-out traditions, whether social, religious or artistic.[38]

Included in this category are Baziotes, Stamos, Brooks, Pollock, Pousette-Dart, Rothko, de Kooning and Gorky, among others. In view of Greenberg's stress on the new space in these artists' works, it is interesting that Ritchie lists the following as characteristic.

> Space treated three-dimensionally; in its variegated depths, shallows and movement related to concepts of space found in landscape. . .[39]

Ferren, McNeil, Tomlin, Reinhardt, Motherwell and Hofmann are labeled "Expressionist Geometric," where space is treated in the following way.

> Space usually treated three-dimensionally and often in a vibrating, pulsating manner, reflecting the inward and outward tensions and thrusts of the forms within the space.[40]

Such discrepancies between Ritchie and Greenberg bring to mind the dictum of Gottlieb who claimed that ". . . any conclusion can apply to any work of art."[41]

It is clear that to Ritchie, the new art is not legitimate by virtue of its intentions or feelings of community. Rather, it is along strictly formal lines that this art finally wins its place. Still, unlike Greenberg who has the same formal preoccupations, we suspect that there is little here that Ritchie would be willing

Plate 7
Willem de Kooning, "Woman I," 1950-52
75-7/8" x 58", oil on canvas
Collection of The Museum of Modern Art, New York

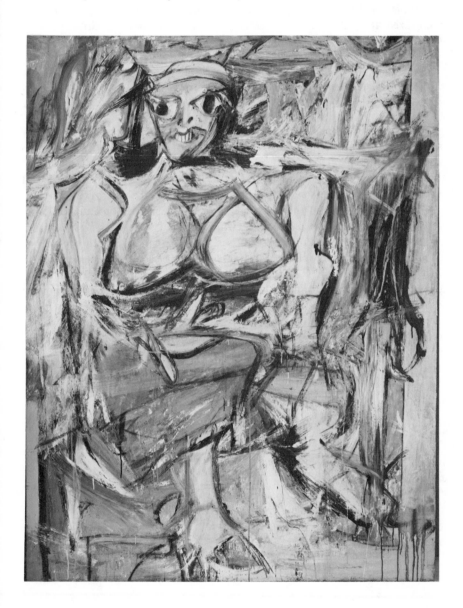

to call revolutionary. In fairness to Ritchie, it is difficult to determine how the new artists could "consolidate" along "revolutionary" lines, a problem which certain of the avant-gardists themselves were unwilling to recognize. To the same extent, it is difficult to conceive of Ritchie's catalogue as "abstract expressionist criticism." This paradox was detected by Hess who, although he recognized the catalogue as essentially sympathetic to the artists, felt constrained to observe the following qualification.

> Although hindered rather than helped by the division of the exhibition into descriptive categories, one finally recognizes the appearance of new forces and styles that are continuations *from* rather than versions of Paris.[42]

The events discussed in this chapter are important because of the new status they bestowed on the art. The standing of the Abstract Expressionists changed from being a "succès de scandale" to being the "School of New York." It was at this same time that the artists began to wonder, by the very fact of their acceptance, if they had not become an academy in the pejorative sense.

The new success of the painting had wide implications for future criticism as well. Traditional critical strategies, which prior to the early fifties had been reserved as the property of conservatives for their application to proven art, suddenly became appropriate for explaining Abstract Expressionism. This acceptance among critics is reflected in the increased number of publication organs willing to give space to the new art. Besides encouraging the expansion of critical approaches to the new art, success also encouraged the concentration of certain positions, whose close identification with the early stages of the movement suggested that their ultimate fate would depend on the fate of the painting itself. It is this concentration and expansion of criticism, begun in the early fifties, that I wish to examine in the next two chapters.

Rosenberg and Greenberg in the Fifties

Through all the activity in the early fifties Rosenberg and Greenberg, now, perhaps, joined by Hess, retained their leadership as spokesmen for the new movement. What became clear in the fifties is that these positions were conceived by their authors as mutually exclusive. The ensuing dialogue then assumed more of the character of a dispute; indeed, the temperature of the dispute often suggests another, more appropriate word, such as war. Given this situation, it is not surprising that each of these critics, particularly Greenberg, Rosenberg and their disciples, firmed up their systems into something more akin to a philosophy than a mere strategy. Good examples of their mature criticisms appear in "The American Action Painters" (1952) by Rosenberg[1] and "American-Type Painting" (1955) by Greenberg.[2]

The most important single factor to provoke the polarization between Greenberg and Rosenberg was the appearance of the latter's 1952 article, perhaps, the most controversial piece of criticism ever to address the post-war American painting scene. Rosenberg's separation of the new art from the rest of modernism derives from his conviction that the new painters recognize a new function for art. But in spite of this separation, he does not want to defend the notion that the new painting constitutes a school.

> A School is the result of the linkage of practice with terminology—different paintings are affected by the same words. In the American vanguard the words, as we shall see, belong not to the art but to the individual artists.[3]

What these painters have in common, then, must be located in what they think, and not in what they do, which is governed along purely individual lines. Rosenberg here recognizes the problem, already encountered in previous literature, of grouping the new paintings. Ignored by almost every one of his detractors, and, perhaps more surprisingly, his defenders, this important premise to his writing cannot be overstressed. Rosenberg apparently feels that the time is not right for traditional critical procedure. Unlike earlier American modernisms, which he views as "training based on a new conception of what art is, rather than original work demonstrating what art is about to become,"[4] the new work remains ahead of any "conception" of what art should be. What Rosenberg seeks to describe, then, is not the art but the consciousness of a new function for

painting. Thus the famous passage. "At a certain moment the canvas began to appear to one American painter after another as an arena in which to act. . . . What was to go on the canvas was not a picture but an event. . . . The image would be the result of this encounter."[5] What Rosenberg means by this is clarified later in the essay.

> With traditional esthetic references discarded as irrelevant, what gives the canvas its meaning is not psychological data, but 'role,' the way the artist organizes his emotional and intellectual energy as if he were in a living situation.[6]

Meaning, for him, resides not in the thing, but in the behavioral context the thing is embedded in. Language for Rosenberg is not only after the fact, but is still unsuited to talking of anything but "things," and therefore incapable of talking about an act.[7] It is understandable that Rosenberg is reluctant to see this activity as "artistic" or the product as a "pure art of perfect relations of space and color."[8] The importance of Rosenberg's criticism, then, seems to involve a new notion of the intrinsic character of meaning. As Quine has put it, ". . . it is the very facts about meaning, not the entities meant, that must be construed in terms of behavior."[9] Rosenberg is consistent when he continues with the following. "The act-painting is of the same metaphysical substance as the artist's existence. The new painting has broken down every distinction between art and life. It follows that anything is relevant to it. . . . Anything but art criticism."[10]

Rosenberg is not entirely consistent on these points, however. It is passages like the following which have left him vulnerable to hostile criticism, and which allowed his critics to ignore his major point.

> Criticism must begin by recognizing in the painting the assumptions inherent in its mode of creation. He must become a connoisseur of the gradations between the automatic, the spontaneous, the evoked.[11]

As Rosenberg himself indicates, you cannot have it both ways.[12] The logic of his central argument militates against connoisseurship, "recognizing in the painting," and "mode(s) of creation." He is now, himself, concentrating on the thingly character of the work. He also compromises his position by imputing rather specific motives to the artists' actions, as "a gesture of liberation, from Value-political, esthetic, moral."[13] Gone is the notion, put forward by Rosenberg himself in *Possibilities,* that what would emerge from the artist's "conversion of energy" would be left open.[14] Rosenberg is right in thinking "an action is not a matter of taste," but wrong in suggesting that "liberation," a word which, after all, describes reasons for acting, is not.[15]

"American-Type Painting" (1955) represents one of Greenberg's best pieces in the fifties and implicitly challenges Rosenberg's position. Following up

his reductionist notions, stated from as early as 1940,[16] Greenberg attempts to justify the turmoil in the painting scene, and no doubt, by extension, the critical sense, by demonstrating that this unsettledness depends on painting's historical position at the moment.

> That is, the avant-garde survives in painting because painting has not yet reached the point of modernization where its discarding of inherited conventions must stop lest it cease to be viable as art.[17]

This same turmoil, in Greenberg's eyes, justifies his conviction that American painting is leading the field, and that it represents the last word in the "modernization" of painting. Nevertheless, "advanced" painting is only achievable by recognizing its relation to the past, and there is never any question in Greenberg, as there was in Rosenberg, that the art he describes remains art. "To produce important art it is necessary as a rule to digest the major art of the preceding period, or periods. This is as true today as ever."[18] Of the abstract expressionist's debt to tradition, the thorough and early assimilation of Klee and Miro, ". . . this, ten years before either master became a serious influence in Paris,"[19] the interest in Matisse, perpetuated by Avery and Hofmann, and the overarching influence of Picasso and Kandinsky are the most important. It was particularly the Picasso of the 1930s, and Klee, both of whom expressed more in potentialities than in realizations, who permitted new directions. But it was also Picasso who posed the biggest problems in strictly pictorial terms—both in terms of the limited depth demonstrated in his work since his synthetic period, and in the "faired, more or less simple lines and curves" in the drawing that accompanied it.[20] Thus, the richness of the painting culture among Americans acted both as a constraint and challenge. It was through such a dialectical process or exchange with history that artists like Gorky and de Kooning were able to make advances; these notwithstanding the fact that Greenberg views both these artists as "late Cubists."[21]

Hofmann, essentially an easel painter according to Greenberg, also reformed certain formal premises of contemporary painting, primarily the notion that "pictorial structure be presented in contrasts of dark and light, or value."[22]

Greenberg's commitment to his critical system can be gauged from his discussion of Pollock ". . . who remained close to cubism until at least 1946, and the early greatness of his art can be taken as a fulfillment of things that Picasso had not brought beyond a state of promise in his 1932-1940 period."[23] His connection with Surrealism is barely mentioned.

The leitmotif of Greenberg's criticism in the sixties also became apparent here in his discussions of Still, Newman, and Rothko. The problem they are involved with, according to Greenberg, is the rejection of, and substitution for the traditional ways of depicting space. Until the Abstract Expressionists, he

believes, painting had depended on value contrasts; ". . . and it has also been its chief agent of structure and unity."[24] The solution the Abstract Expressionists offer to this ". . . technical resource whose capacity to yield convincing form and unity is nearing exhaustion," is seen by Greenberg as the most radical of all developments in the painting of the last two decades, and one that depended on a knowledge of the late Monet.[25]

> Though Still led the way in opening the picture down the middle and in bringing large, uninterrupted areas of uniform color into subtle and yet spectacular opposition, Newman studied Impressionism for himself, and has drawn its consequences more radically. The powers of color he employs to make a picture are conceived with an ultimate strictness: color is to function as hue and nothing else, and contrasts are to be sought with the least possible help of differences in value, saturation, or warmth.[26] (Plate 8)

Of the three, only Rothko maintains some interest in value contrasts, something in the manner of Matisse.

Although Greenberg and Rosenberg contributed much to the literature of the fifties, in neither case did the basic critical model undergo any radical change. If any change is detected in their later literature, it is the even further refinement of issues already on the board. Since this is the case, I will make no further attempt to cover their respective literatures in the fifties and will mention them again only insofar as they affected, or were affected by, the new artistic scene in the sixties.

Plate 8
Barnett Newman, "Vir Heroicus Sublimis," 1950-51
7' 11 3/8" x 17' 9 1/4", oil on canvas
Collection of The Museum of Modern Art, New York
Gift of Mr. and Mrs. Ben Heller, 1969

The Normalization of Criticism in the Fifties

As Greenberg's and Rosenberg's critical designs hardened, it became more apparent to other critics that they were essentially serving a polemical function. This, in combination with the recent successes of Abstract Expressionism, such as the large attendance and favorable critical reception of the "salons," the Ritchie show at the Museum of Modern Art, and the increasing representation of the artists in the galleries, led critics to examine abstract expressionist pictures, rather than their historical position, as potential material for criticism. For, it was the success of abstract expressionist painting which was assured in the fifties, not abstract expressionist criticism, which was still under considerable suspicion. The variety of criticism in the fifties is so great that only the smallest sample can be indicated here. This brevity is also justified on the grounds that this is no longer "abstract-expressionist criticism" in the sense that is the only justifiable way of speaking of such a thing. Rather, in such later literature, we are concerned with what might be described as the variety of criticisms addressed to abstract expressionist painting. What all this literature has in common is its attempt to re-open critical options.

A good example of this normalized criticism appears in B.H. Friedman's "The New Baroque." Friedman maintains that contemporary American art represents a stage of modernism, which itself began with the demise of Romanticism and which he calls "neo-baroque romanticism."[1] As such, he finds in it many analogies with late phases of the Renaissance tradition. His notion of "the old baroque" is supplied by Aldous Huxley in his essay, "Death and the Baroque."

> . . . pictorial compositions try to break out of their frames. Where there was (in the Renaissance) understatement, there is now emphasis. Where there was measure and humanity there is now the enormous, the astounding, the demi-god and epileptic sub-man. . . . baroque artists were committed to a systematic exploitation of the inordinate.[2]

The key word for Friedman is "inordinate," which he proceeds to define, and by virtue of which he concludes that "in terms of this definition, we would maintain that the so-called abstract expressionists, like their baroque predecessors, are most inordinate in the realm of technique . . . Technique and effect become ends in themselves."[3]

Friedman is anxious to avoid viewing this baroque phase as intrinsically bad, but at the same time wishes to point out that it has its own kind of dangers. "If . . . an artist remains true to his experimentation, leads rather than is led by his new techniques and theories, the baroque need not disintegrate into the rococo and the purely decorative" (as it did, according to Friedman, in Kandinsky).[4]

> But it is evident in the most recent work by Pollock, as in that of De Kooning and younger painters like Rivers, that these artists see the rococo dead end of the statementless decoration which is facing them, and wish to return to a more formally organized kind of painting.[5]

The Friedman article is particularly interesting in view of the Wölfflinian cast of history which he shares with Greenberg. Their respective criticisms, however, could hardly be more different. While they both invoke Wölfflin's formal categories, Friedman, unlike Greenberg, is concerned with what these mean in affective dimensions as well. And the concentration on artistic means, viewed by Greenberg as modernist purification, represents a near dead-end—a rococo self-indulgence—for Friedman.

> In baroque the sky is literally the limit. A theme is pushed as far as it will go; it is not developed logically and economically to a conclusion as in Renaissance and classical art. The inordinate is exploited.[6]

Friedman, having tamed this new and revolutionary art to his satisfaction, is able to conclude the following. "Those artists who are frequently unsympathetic to the work of a baroque artist like Peter Paul Rubens are, in fact, trying to be the Rubenses of our time."[7]

Friedman is fairly routine in comparison with much of this later literature and only serves as a prelude to an essay like Robert Rosenblum's "The Abstract Sublime." For Friedman's baroque category, Rosenblum substitutes the "sublime."

Attributes of the sublime for which Rosenblum finds analogies in the new American painting (particularly Still, Rothko, Newman and Pollock) include size, obscurity (a "bewildering structure" comparable to their size), boundlessness, "immeasurable spaces and incalculable energies," and more.[8] Unlike Greenberg, however, who has developed a formal vocabulary to cover some of the same phenomena, Rosenblum is unwilling to stop with formal considerations:

> Much has been written about how these four masters of the Abstract Sublime have rejected the cubist tradition and replaced its geometric vocabulary and intellectual structure with a new kind of space created by flattened, spreading expanses of light, color and plane.

But in America it is equally important to recognize that "in its heroic search for a private myth to embody the sublime power of the supernatural, the art of Still and Rothko, Pollock and Newman should remind us once more that the disturbing heritage of the Romantics has not yet been exhausted."[9]

More important in characterizing his writing than the categories themselves (or the history of the categories) is the easy transition he makes from history to the present *through* these categories.

> . . . 'Gordale Scar' is meant to stun the spectator into an experience of the sublime that may well be unparalleled in painting until a work like Clyfford Still's '1957-D.'[10]

He then quotes Edmund Burke, familiar to the Abstract Expressionists through the avid readership of Newman: "Greatness of dimension is a powerful cause of the sublime," and concludes that ". . . indeed, in both Ward and Still, the spectator is first awed by the sheer magnitude of the sight before him. (Ward's canvas is 131 by 166 inches; Still's, 114½ by 160 inches.)"[11] Regarding the compositions, Rosenblum finds the following comparison.

> In the Ward, the chasms and cascades, whose vertiginous heights transform the ox, deer and cattle into Lilliputian toys, are spread out into unpredictable patterns of jagged silhouettes. . . . In the Still, Ward's limestone cliffs have been translated into abstract geology, but the effects are substantially the same.[12]

Citing more of these parallels would only end in reproducing the article, for the entire piece is composed around such comparisons. It is worth stressing, however, that the pictorial compositions are of the same sort; for example, Still's "1956-D" with James Ward's "Gordale Scar," and Rothko's "Light, Earth, and Blue" (1954) with Friedrich's "Monk by the Sea" and Turner's "Snowstorm." Abstract Expressionism has, by this time, been thoroughly assimilated into history—both into the history of art and the history of taste.

John McCoubrey, in "The New Image," has used some of the same sort of explanations.

> In American paintings, space has tended to be a shapeless void, not an atmosphere or a palpable ambiance, but an emptiness . . . Figures, as we have seen, do not command this space, but live tentatively within it and are given, for the purposes of picture making, only the barest means to contend with its emptiness.[13]

This and the following passage both recall aspects of Rosenblum's discussion.

> In the total configuration of painting by Pollock, Kline, and DeKooning, not in their size alone, the nature and effect of American space is felt. . . . The viewer is thrust abruptly into the space of the picture, much as he was into Cole's Catskills.[14]

Unlike Rosenblum, however, McCoubrey isolates the character of this space as peculiarly American. "They [the American painters of the forties and fifties] looked only along the edges of the European tradition, avoiding, as earlier American painters had already done, not only the magisterial works which tradition had produced, but also the certainties which it alone could provide."[15] In this sense, McCoubrey recalls Rosenberg's notion of "coonskinism," and the same sense of the extremity of the artist's existence pervades his writing.

Another approach is provided by William Seitz, who, although he relies heavily on formalism, also finds this art a "pictorial" reflection of the "spirit" of the times. And this, for Seitz, involves the dynamics of the cosmos—". . . Life rhythm and the dynamic resolution of antitheses."[16] This expresses the same easy approach to the subject and simply tends to situate its final rationale less inside the art object than outside it. Like the other authors, Seitz finds facile analogies in the history of art, an example of which appears in his discussion of Tobey.

> From his teacher, Teng Kwei, he learned 'the difference between volume and the living line,' so that 'what was once a tree became a springing rhythm.'[17]

I find this comparison, which depends on attributes in the work, significantly different from the highly speculative interest in the East exhibited by the artists in the forties. Nevertheless, Seitz's remarks are certainly a result of that experience.

Two years later, in his dissertation, Seitz presented the most extended discussion of the movement to that date and, in many respects, to the present. "It is my intention to plot certain of the shifting positions of painting during the postwar decade, and to ascertain something of the 'unknown center' postulated by their arrangement."[18] According to Seitz, his intention "implies a tacit belief in Zeitgeist: a constellation of ideas which seem to be in the atmosphere."[19] Although not conceived as history, "It is only as history that such a study can gain its fullest meaning . . . Since their origins in the nineteenth century, 'spirit history' and 'style history' have challenged scholars, artists, and critics."[20]

Although there are many excellent formal descriptions of the works, reports of the artists' statements and of ideas in the air, Seitz' cumulative or multi-perspective approach never allows him to achieve a thesis. He becomes the reporter of so many points of view, often contradictory ones, that he is unable to claim the advocacy of any of them—a fact that is not necessarily at odds with his declared aims. The following is typical of his prose style.

> Light to Tobey, is a content. In a Neo-Platonic sense, he identifies it with Christ and the Logos; his white lines symbolize light as a unifying idea; he has spoken of Turner as greater than the Impressionist because he 'dissolved' everything into

light . . . [Light] not only takes the form of a 'graphic style' to which Hofmann objects, but of precisely the 'over-all effect' which he finds so destructive to color interval.[21]

A slightly later and somewhat more historical variation of criticism appears in Goldwater's "Reflections on the New York School." To the extent that it is historical, it anticipates the so-called historian-critics of the sixties, of which William Rubin is an example. We feel for the first time, perhaps, that the movement is capable of being viewed as a closed historical movement, and one capable of yielding a cool and balanced account by a critic. In introducing this historical ingredient, Goldwater seems to conceive of his article as a corrective to certain pieces of the earlier literature. Examining a few of his concerns will serve to emphasize the cool and careful character of his assessment of this heretofore irritated, and irritating, movement.

Goldwater recognizes the difficulty of establishing communal lines along formal traits in the works, but he does not insist that there are none. "Thus for the artists themselves, specialists within a language that is their mother tongue, whose rudiments others must still learn to decipher, slight distinctions have important connotations."[22] At the same time, Goldwater recognizes that community interests operate socially as well.

Here [the W.P.A.] undoubtedly is one of the sources of that extraordinary gregarious intimacy (in New York, and in the summers on Long Island) that has been the paradoxical accompaniment of the New York School's assertion of individual uniqueness.[23]

Even more interesting is that the notion of "crisis" is cast in an historian's vocabulary, and as such, goes far to clarify the polemical character of Greenberg's, Rosenberg's and Hess' crises.

Brought face to face with the fact that their art was a non-viable economic commodity, but absolved by the general state of affairs from seeking the causes in art itself (since the whole of society was finding it hard to market its skills), the non-sale of these works in the future (the fifteen years of struggle that preceded the present boom), would hold no terrors for them, nor reflect in any way on the value of their art nor on themselves for being artists.[24]

It is interesting to note that of all the major critics, Hess is probably closest to Goldwater in this respect.

Like the other critics of the fifties just noted, Goldwater is anxious to legitimize the movement by pointing out its analogues in the history of art and criticism. Thus, inspiration, "the happy accident" (a continuation of Delacroix), "the struggle with the canvas" (a paraphrase of Cezanne's "inability to realize") and other notions entertained by the Abstract Expressionists find their

equivalents in history.[25] Goldwater's commitment to traditional critical goals
has already been discussed in an earlier section of this book. Even in 1960 he
believed the notion of action painting was misleading and insisted on viewing the
movement through its works. The conclusions he reaches from his examination
of the objects, however, differ radically from Greenberg's.

> . . . Judged by their finished works, as they are best judged (and as they judge each
> other), here are artists who like the materials of their art: the texture of paint and
> the sweep of the brush, the contrast of color and its nuance, the plain fact of the
> harmonious concatenation of so much of art's underlying physical basis to be en-
> joyed as such. They have become fine craftsmen with all the satisfaction that a
> craftsman feels in the controlled manipulation of his art, and all his ability to handle
> his medium so that his pleasure is transmitted to the beholder.[26]

Just as Goldwater and others were determined to put Abstract Expression-
ism into history, Schapiro sought to put the whole phenomenon of the avant-
garde into history. With the success of the movement came the understandable
conclusion that this avant-garde, like the whole series of venerable avant-gardes
dating from the mid-nineteenth century, was historically necessary to meet "the
challenges of new possibilities." In fact, it is hard to conceive of Abstract Ex-
pressionism as a continuation of modernism without enlisting avant-garde
qualities—a fact which Greenberg and Rosenberg had both appreciated.

Although Schapiro briefly traces the historical goals of the avant-garde,
names of contemporary Americans are conspicuously absent. His purpose
seems to be nothing more than to encourage a wider acceptance of experimenta-
tion.

> Painting by its impressive example of inner freedom and inventiveness and by its
> fidelity to artistic goals, which include the mastery of the formless and accidental,
> helps to maintain the critical spirit and the ideals of creativeness, sincerity, and self-
> reliance, which are indispensable to the life of our culture.[27]

The application of these traditional critical means to the new painting
seemed to be justified on other grounds as well. Part of this involved the growth
of a new literature, on the part of critics interested in psychology of art and
vision, which expressed a reluctance to sanction certain fundamental premises
put forward by earlier abstract expressionist critics. Although this had little
effect, at this late stage, on whether the art was viewed as a success or a failure,
it did bring many critical assumptions (especially those of Rosenberg and the
artists) under suspicion. Leon Golub, for example, in "A Critique of Abstract
Expressionism," challenged the kinds of claims critics and artists had made for
the communicability of abstract expressionist work and deserves quoting at
some length.

. . . Especially peculiar to abstract expressionism is the terminological remoteness of the purposes attributed to it. The claims made for one painting could easily typify works by other artists.

As Alfred Russell (*Art Digest,* November 15, 1953) writes: 'The limitations of the non-objective idiom are its vastness, its lack of measure, its all-inclusiveness. It tends to equate all possible knowledge—especially intuitions of extra-spatial, non-Euclidian metaphors; the language of sign and symbol; the unconscious, and the laws of chance.' There are no uniform or iconographic means (or for that matter, any notation corresponding to any scientific interpretation) through which the supra-formal aspects of such paintings could be defined. The ambiguities of abstract expressionism force the viewer to locate the extrinsic focus—in that the observer reacts through an allusive, self-referential perception. The observer does perceive variously accelerated or structured linear configurations; the attributes of these relations are so abstract, however, as to be incommensurable—these then can hardly be couched in metaphysical terms (unless the very negation of communicable content can be metaphysically construed).[28]

A different, but equally thorny, problem is raised by Rudolf Arnheim in "The Artist Conscious and Subconscious." His point has less to do with the professed communicability of abstract expressionist content than with its significance or lack of it. While he is perfectly willing to concede the importance of investigations into the subconscious, he is less sure that what is culled from the subconscious is *necessarily* significant.

. . . today in both psychology and the arts, there is a danger of confusing the elementary with the profound. Cultures, in their late, refined stages seem to develop a weakness for primitivism, and one of the forms this inclination takes in our own case is the temptation to believe that the areas of the mind farthest away from consciousness harbor the deepest wisdom. This belief strikes me as a romantic superstition. The elementary or—to use a fashionable term—the archetypal statement has the simple strength of a primitive icon, but in its raw state it is acceptable to the developed mind only as an escape from the confusion of complexity or as a spice for the tired palate. It is a medication rather than a revelation because in order to meet the requirements of our intricate civilization the fundamental images of human experience must be modulated by the conditions, traditions, memories and thoughts that make us what we are.[29]

Such challenges by competent and serious people tended to give comfort to a variety of other less responsible authors. These ranged from extreme rightists and sensationalists to more serious, but essentially conservative, critics. Abstract Expressionism had always had its detractors, of course—a few from the early days of the movement have been mentioned—but this lighter brand of hostile criticism does not constitute a major consideration. The few examples I will mention here are simply intended to fill out a side of the critical scene which might appear, from the emphases in this study, to be a dialogue between Rosenberg and Greenberg, and early and late.

Among the conservative critics, Hilton Kramer has stood out for some time as the leading spokesman for a "return to the figure." Much in the fashion of Greenberg and Rosenberg, Kramer realizes the problem, or crisis situation, of the American artist and states it in much the same way.

> The problem which American painters face today is roughly similar to that which faced Pound, Eliot, and their contemporaries in poetry forty years ago, with this crucial difference; four decades have removed most of the glittering possibilities without providing anything to take their place. . . . Forty years later it does not seem likely that the European tradition can be used in a new way, and Europe itself is less a setting for expatriate artistic activity than for the spending of American tourist dollars.[30]

Unlike the other two critics, however, Kramer sees Abstract Expressionism as merely ". . . another casualty of that perennial depression out of which American painting had not yet been able to bring itself."[31] This statement appears in "The New American Painting" and it, as well as the rest of the article, addresses the problems raised by Rosenberg's "The American Action Painters."

Kramer finds Rosenberg difficult on several points, some of which continue to plague Rosenberg's critics to the present day. An example is his strict separation of the American and European developments, and Rosenberg's implication that this corresponds to a division between non-art and art. This separation, according to Kramer, obscures the point where "his critical insight evaporates into apology and where his apology is scarcely distinguishable from what a less friendly critic would write as an indictment."[32]

> . . . from Mr. Rosenberg's account of his subject, some new transformations must take place in the art critic: he must be a dramatic critic or maybe a biographer or maybe a psychologist or maybe a metaphysician. If he risks being an art critic, he risks being a stranger.[33]

Several years later Kramer restated his dissatisfaction in "Critics of American Painting," where his earlier good humor largely disappeared.

> Between obscurantism on the one hand and demagoguery on the other, there has been very little to choose from in recent art criticism. One has been a defense which is also a form of collaboration—and the other has been a pandering to it. Neither has been willing to take on the classic critical task: the elucidation of the work of art itself. . . .[34]

It is the first of these—the defense—which he criticizes in 1953. It is the latter—the pandering—which he now takes up, with particular attention to "The Great American Artist Series" published by George Braziller. Goossens, Hess, and O'Hara, writing on Davis, de Kooning and Pollock respectively, are his main

targets. All of these three, according to Kramer, ". . . are simply insults to the intelligence. I don't wonder that no editor has been named for this series. It would take courage to stand up in public and take the rap for such shoddiness and pretention."[35] Kramer finds it hard to overstate his revulsion for what he terms the "poetical" school of criticism.

"When it comes to Messrs. Hess and O'Hara, I must resort to some lengthy quotation just to make their commentaries *believable.*" Having then quoted sizable sections from Hess's book, Kramer continues,

> . . . How is one to characterize such writing? That it has nothing to do with art is certain. It has muscled its way into the 'poetical' school of criticism out of some misguided idea that only in those fetid ranks is it possible to be 'profound.' Well, nothing could be more removed from poetry, of course. These writers always forget that the superiority of poetry over prose consists in its being *more* precise, not less. . . . Maybe it's the garbage in that 'garbage-choked river.'[36]

Less responsible and sincere versions of this declamatory literature abound in the fifties and Frank Getlein's contributions are nearly legendary. Yet, to illustrate this vein of criticism, I select a piece called "The New American Painting" by Geoffrey Wagner. What for Kramer had represented a serious deficiency in art criticism became for Wagner the opportunity to be witty and derogatory, and, apparently, to his way of thinking, entertaining. Buoyed up by critics like Maurice Grosser, Howard Devree, Emily Genauer, and Lincoln Kirstein, Wagner characterizes the New York School as the "drip, splash, gouge, spray, or rub-a-dub school."[37] And all of the advanced critics—Hess, Rosenberg, and Greenberg—get their share of ridicule. The following statement is his concluding remark on the current state of affairs in 1954.

> No one dares say so, but 'action' painting, encouraged by interested critics, fostered by some all-too-innocent museums, creamed to a lather by the constant publicity given it in the glossy press of Luce, 'Look,' and 'Vogue' (where Cecil Beaton's models lounge against a Pollock wall), has betrayed contemporary painting in our country in a big way. Pollock and the Kootz gang have almost personally put back our painting some thirty years or so. The gorillas are upon us all right. Speciously 'highbrow,' openly anti-humanitarian, this is the art of rough necks for whom the creative instinct is a veritable 'bête noire' and most of whose ideas, I suggest, might politely be given the bum's rush.[38]

There is little one can say about such a piece, which seems to miss all the issues and more closely resembles a temper tantrum than art criticism. It is certain, however, that such writing no longer sought to meet the threat of Abstract Expressionism and its "hired hacks," but was complaining, rather, of its success.

Criticism in the Sixties

By 1960 and in cases even earlier, critics had felt that Abstract Expressionism showed signs of becoming an academy. Their own concern was soon rendered academic with the lightning success of Pop Art. The bulk of criticism in the sixties was redirected toward this and other new developments while discussions of Abstract Expressionism increasingly became re-evaluative and retrospective critiques.

The publication of *It Is* (Spring 1958, Spring 1960), an enterprise guided largely by second-generation interests, clearly demonstrated that the crisis was over for the Abstract Expressionist. Adapted from Bishop Butler's "Everything is what is is and not another thing," the very title of the document denied the ontological dilemma posed by many first-generation masters and critics of Rosenberg's persuasion.[1]

Both Greenberg and Rosenberg still wrote, but in the sixties Greenberg clearly had the advantage. Albers' note to Rosenberg to the effect that "Angst is dead" reflected the "cool scene" which had little use for an existential or crisis vocabulary.

By contrast, Greenberg's prophecy of stylistic directions, at least to many minds, had come true, and the popularity of his methods was maintained, most notably by Michael Fried, Jane Harrison Cone and Rosalind Krauss. But in the cases of all the younger critics the object of their critical concerns became less Abstract Expressionism and more the application of their critical models to subsequently styles, and therefore tangent to the issues at hand.

The concentration of *It Is* on the object and its insistence on what is essentially an empirical attitude probably reflects both the chronological removal from the crisis and the rising star of Greenberg's criticism. Nicolas Calas points out that they could have found their philosophical justification in Wittgenstein who claims that ". . . We must do away with all explanation, and description alone must take its place."[2] Wittgenstein's *Philosophical Investigations* were, in fact, published posthumously in 1953. Many critics, provoked by a certain embarrassment over the state of aesthetics as a scientific philosophy, attempted to relate themselves to a broader current of empiricist philosophy known as "philosophical analysis." As such, they represent an opposite direction from that taken by a group of critics generally known as "historian-critics," of which more will be said shortly.

In describing the analytical school of philosophical thought, Monroe Beardsley has pointed out that properly speaking, the exponent of this kind of thinking

> is not in a position, qua philosopher, to supply information that is needed for the [any] dispute to be resolved; nevertheless he can be of enormous help, if he can show that this resolution is hindered by the vagueness or the ambiguity of key terms, or that some of the inferences are logically faulty, or that the question itself is posed in a misleading, even perhaps self-defeating, manner.[3]

The trouble with assigning this position to our contemporary critics is, of course, that not one of them is willing to assume the role of philosopher. Rather, Wittgenstein is used as a defense of certain routine, usually Greenbergian, critical practices in a rather simple-minded and polemical way.

In any case, the editor of *It Is,* Phillip Pavia, set the tone of the succeeding issues and reflected both his removal from the crisis of the forties and the then-current dedication to Greenberg's kind of critical method.

> . . . There is no mistake about the direction: no dream, no history, just the problem and the individual; as if 'the first few sensations we are born with' (Cézanne) were realized as a pure art experience for the first time.[4]

Pavia identifies the "problem," surely the key work in this passage, as "a new irregular ratio" of light and space. His evaluation of earlier century avant-gardes and, implicitly, of the first-generation Abstract Expressionists, is very clear in the following polemic.

> All Surrealists, illustrative or abstract, sincerely hate Mondrian's guts. . . . He was like David in the old story: he had a sling-shot, well-aimed. And never has a cemetery been dug so deep nor filled so high with dead surrealistic art—all from a simple sling-shot. . . .
>
> The Surrealist-Abstractionist's premise, an extension of the Surrealist-Illustrator's, was simply based on the dream. Only reverie, primordial associations, myths, symbols, they reasoned, could make new plastic experience for the modern artist; . . . It is an art wrong at the bottom and good on the top. It resembles some of the Medieval 'Morality Plays.' The moral in these dramas was simple and invariably the same. The person in the play, whoever he was, was a good, good man but (and this was the point) his premise was evil and wrong.[5]

Opinion was not undivided in the first issue, however, and Ray Parker, obviously in great debt to Rosenberg, was permitted to say the following:

> The painting is both a thing and an event. Ontologically, it exists as a part of nature, not only as an 'esthetic' object, but as behavior in the form of a significant record.

> While the Painter's subject is the painting the painting's subject is the painter himself as his experience is consummated in the making.[6]

It will be recalled that in the "polemic" of the first issue, authored by Pavia, Mondrian emerged as something of a hero. In the second number, some of his unpublished writing appears—examples which presumably demonstrate the contemporary necessity for art's being abstract.[7] It is also curious that some of the younger artists, sympathetic to Abstract Expressionism, but deprived of a crisis in the sense of the forties, felt that they had to re-fight a battle which had already been won. After that fashion, Crehen, in the first issue, had made much of the fact that Abstract Expressionism has "survival value."[8] Such a concern was understandable for Hess and others in the late forties and early fifties, but by the time of *It Is* one cannot help feeling that the authors are setting up dummy issues.

One of the most interesting, and in view of the older artists' views on the subject, one of the most surprising aspects of *It Is* pertains to the "Manifesto-in-Progress," written in successive issues by Pavia. Almost in historical order, he sets about to say the final word on all the major issues that the older generation were concerned with. In the second issue, for example, Pavia discusses a new sense of space which has "forced the refinement of light"—and discusses it in a very Greenbergian way.[9] In the third issue, he takes up the concept of "association" and treats it much in the manner of Rothko and Gottlieb, in their letter to the *Times* of 1943.

> 'Association' . . . is most important for it is the real connecting link between sensations. Abstract artists must be aware, however, that the ordinary way of associative experience can become deadly, especially since the characteristic function of the linking of sensations is 'filling-in with pastness.' Associating present sensations with past experience is normal and even necessary in everyday living, but such associations are poisonous in creating art. [10]

> . . . history is dispensable.[11]

The effort to purify art, so much a concern of Greenberg and the second-generation artists, is transposed to another concern in the fourth issue. For Pavia, not only the pictorial elements of the work, but also the psychology governing the creation of art must be purified. "At this point we are discovering in human nature the hidden effects which make habit a foundation of history, obstructing 'non-history' experiences."[12] Again this recalls the statements of some of the first-generation artists and to the extent that he is interested in pure experience, Greenberg's debt to Dewey.

It is understandable in view of the empirical attitude of the younger Abstract Expressionists, that between Rosenberg and Greenberg, the latter

enjoyed more favor in the late fifties and sixties. In neither case, however, did the content of their criticism change significantly in the sixties. Greenberg, partly by historical accident, found himself applying his criticism to a style where it appeared to fit better than it had ever fit the Abstract Expressionists. And his criticism had always been less vulnerable to charges of not speaking to the work of art than Rosenberg's, a matter which had assumed major importance in the minds of the younger critics. Rosenberg, for his part, found himself without a crisis, a fact requiring his constant redefinition of "anxiety" and other favorite words in his critical vocabulary. The persistence of their use in the sixties tended to date his criticism. In contrast, Greenberg's vocabulary actually acquired more authority with the appearance of "Op," color field, and minimal painting ("post-painterly abstraction" in Greenberg's own words).

One of the major challenges to Rosenberg's version of "action painting," as an event, came from Mary McCarthy, who stated in her review of *The Tradition of the New* that "you cannot hang an event on the wall, only a picture."[13] Rosenberg's reply to this criticism clarifies the stress this book has put on the behavioral matrix formulated by Rosenberg for the acquisition of meaning within the work. Rosenberg paraphrases McCarthy in the following way. Even though the artist's intent may be to "abolish art" in favor of the act, paintings are ". . . in the realm of things made, not deeds done." The critic's job, then, becomes one of informing the spectator about which among "these things made," are good and which are bad.[14] While Rosenberg tends to accept this approach to "historical" objects, he maintains that ". . . in dealing with new things there is a question that precedes that of good or bad. We refer to the question, 'What is it?'—the question of identity."[15]

> Only if, through the habit of looking back to other times, we forget the multiple existence which a painting now enjoys in separation from its physical body [do we find a contradiction]; its ghostly presence through reproduction in books and magazines that carry it *as picture* far from its durable being of paint and canvas; the intellectual character it takes on from the interpretations inevitably take to it by critics, historians, psychiatrists, philosophers of culture; its role in the political factions and in the educational activities of international institutions; the power of transformation it wields over its own creator through the energy it accumulates on its passage through the social orbit.[16]

The same point is made in *The Anxious Object* where the meaning of contemporary art, for Rosenberg, involves the notion of anxiety, but not anxiety of the simple-minded "suffering artist" sort.

> The anxiety of art is a peculiar sort of insight. It arises, not as a reflex to the condition of artists [a condition much exploited in previous explanations of the international Paris bohemia], but from their reflection upon the role of art among other human activities.[17]

Finally, he warns that ". . . the present emphasis in art criticism on the end product, rather than on the problematical nature of the art undertaking, opens the way to art produced under direction, as in related professions,"[18] a comment surely intended for his arch-rival, Clement Greenberg.

Although I believe an interpretation of Rosenberg's criticism along the line of meaning suggested here offers the most rewarding view of his work, it would not be difficult to impute too much of this to Rosenberg's own intentions. It must be conceded to his critics that logical consistency is not a particular concern of his, as the following passage shows.

> Instead of solving his problem—'his' because he has chosen it—the artist lives through the intrumentality of his materials. By fixing his idea in matter he exposes either the crudeness of his thought or the clumsiness of his art; thus he is led to experiment and refinement. In time, he becomes so adept in materializing as if they were meanings, that the problem itself is transformed.[19]

Rosenberg's logical problem here is not, I believe, in his noting that the artist "lives it through the instrumentality of his materials," but the inconsistency of this with his view of the artist manipulating his materials as if they were meanings. This leaves the reader in considerable confusion as to what Rosenberg thinks meaning is.

In the sixties, Greenberg, for his part, is quite unconcerned over Abstract Expressionism as a revolutionary statement. Since his first views of the movement as a crisis situation, two important things had happened. He had amplified his own notion of history to include Abstract Expressionism, and critics of the fifties showed that this art would submit to fairly routine critical strategies (with the help of a little imagination). How calm Greenberg really is can be gauged from the following remarks which are directed at the Rosenberg camp.

> It looked as though all form, all order, all discipline, had been cast off. . . . one was given to understand that what was involved was an utterly new kind of art that was no longer art in any accepted sense. This was, of course, absurd.[20]

The place of Abstract Expressionism in Greenberg's history of art is what one would expect from the discussion of his earlier work.

> What was mostly involved was the disconcerting effort produced by wide-open painterliness in an abstract context. That context still derived from Cubism—as does the context of every variety of sophisticated abstract art since Cubism, despite all appearances to the contrary. The painterliness itself derived from a tradition of form going back to the Venetians. Abstract Expressionism—or Painterly Abstraction, as I prefer to call it—was very much art, and rooted in the past of art. People should have recognized this the moment they began to be able to recognize differences of quality in Abstract Expressionism.[21]

Greenberg was actually very consistent on these points when no particular challenge was being met. However, in a dispute with the English critic, David Sylvester in 1950, on the merits of the American Pavilion at Venice, he was moved, as he was on a few other occasions, to take a slightly more passionate position.

> At Venice they must have looked too new—new beyond freshness, and therefore violent; and I can understand why the Europeans were puzzled, given also that the experience conveyed is American experience, and still a little recalcitrant to art.[22]

In any case, it is clear by 1954 that Greenberg favored art such as that which was about to supercede Abstract Expressionism.

> . . . the reaction presented here is largely against the manner drawing, and the manner design of Painterly Abstraction, but above all against the last . . . all the artists in this show move towards a physical openness of design, or towards linear clarity, or towards both.[23]

Even in the forties, Greenberg disapproved of the romantic ingredient in the movement and the "obsessiveness" of American painters. The artists of the sixties, to the extent that they continue Abstract Expressionism, continue a vein which is best seen in the work of Still, Newman, Rothko, Motherwell, Gottlieb, ". . . and even Pollock."[24]

That Greenberg's criticism was able to maintain itself throughout the whole duration of the movement and the sixties, even though styles changed radically, is quite remarkable, and owes its success to many factors. Not the least of these is the power of his prose, most dramatically apparent in his carefully revised essays in *Art and Culture*. Furthermore, Greenberg's early devotion to the Abstract Expressionists, coupled with their subsequent success, lent his criticism an unparalleled authority from the mid-forties on; so much so that Noland and Louis were well advised to consult him upon their arrival in New York. The myth that he had prophesied the earlier stages of the movement, or that he had properly defined the inevitable course of history, seemed sufficiently compelling to convince even Greenberg himself, who, more and more, assumed the role of the prophet. Motherwell confirms that fact that "Greenberg was the most respected critic."[25]

Any further discussion of Greenberg's writing in the sixties might embroider, but hardly alter, any of the thoughts basic to his criticism. The importance of his discussions for the sixties and seventies is, however, reflected in two large retrospective exhibitions of the abstract expressionist movement. The first of these, Maurice Tuchman's *New York School: The First Generation,* tacitly accepted the movement as history and implied that it is the yardstick by which all later American art is to be measured.[26] All the earlier members are

cast as old masters with a firmness and finality which their real positions do not yet justify. The catalogue's sampling of critics, artists' statements, and pictures all reflect the editor's desire to omit anything that does not suggest his notion of the New York look. To an extent this may be a desire to let the art speak for itself, but the very implications of such a large and historically viewed exhibition requires more. There is no significant text by Tuchman himself.

More interesting than the catalogue itself is the reply it prompted from Barnett Newman.[27] He claimed, with some justification, that the organizers of the show treated the artists "as if we were all dead," and that the designation of the group as a period-style prematurely cast them in the comparatively dead role of the purely historical. Further complaints included the vastness of the time period covered and the lack of a chronological presentation of the paintings. Most importantly, Newman felt that the show gave no indication of the "visual dialogue" which occurred at any point of the period, and which alone would provide an adequate fulcrum for moving forward or backward in time. The selection of critical writings, he felt, were misleading, since they implied more literature than actually existed, and he views the omission of Hess as a serious one.

The second exhibition, mounted by the Metropolitan Museum in 1970 as part of the program of their newly instituted Department of Contemporary Art, is much the same.[28] The selection of artists' works is shown in alphabetical order, and includes without serious qualification, and presumably as a function of the same "something" which generated the New York School, such different artists as Warhol, Tomlin, Stella, Gorky and Cornell. The notion of community which Geldzahler implicitly endorses is outright specious. He, unlike most earlier critics, doesn't seem to have a motive (except fashionableness) for what he does. His selection of representative criticism includes Rosenberg's "American Action Painters," Rosenblum's "The Abstract Sublime," Greenberg's "After Abstract Expressionism," Rubin's "Arshile Gorky, Surrealism, and the New American Painting," and Fried's "Shape as Form." As such, his selection reflects more the popularity of abstract expressionist criticism than its historical role. Geldzahler, himself, contributes nothing new in his own essay, but does insist on the succession of New York to the position of prewar Paris, a position as unclear as it is popular.

Neither Greenberg nor Rosenberg were representative of what was being said about Abstract Expressionism in a new way. Quite in opposition to earlier criticism, and perhaps most characteristic of commentary in the sixties, is the sacrifice of the traditional enterprises of criticism for history. A literature was produced by a new generation of writers, usually trained in art history departments, whose members have been dubbed historian-critics. They exclude neither the material work of art nor the intention of the artist. Here, the boundaries of the author's superstructure are not involved with community goals of a

polemical sort or aesthetic functions—nor are they described by any particular internal logic of a critical system; rather, it is in describing the specific historical circumstances and iconography of works, in a fairly routine historical way, that this writing distinguishes itself.

An early example of this kind of writing can be found in William Rubin's "Notes on Masson and Pollock."

> Such is the rigor of the new American Chauvinism that the Surrealist background of our postwar painting is often disavowed. But the parthenogenesis of the New York School is a dogma professed by the second generation of Tenth Street rather than by the originators of the style. . . . While Surrealism is anathema to the mentors of *It Is*, painters like Pollock and Motherwell readily affirmed the stimulation they found in the artists of the movement.[29]

While Rubin is indicting the second generation here, he could have fairly pointed out that the first-generation critics were guilty of the same transgression, although not out of ignorance. I have tried to show earlier, in fact, that critics had certain community interests in mind in ignoring or rejecting previous (especially European) traditions of art. Just the same, part of the intentions of such later writers as Rubin is to set these matters right. After a careful discussion of Pollock's relation to the Surrealists, he asserts that ". . . some formal elements were incontestably taken over. This aspect of the debt is difficult to measure, however (and would center around a study of Gorky), but some light may be thrown on it by juxtaposing the work of Masson with that of Pollock."[30] The bulk of the article is then given over to how these two painters may be viewed "as like each other," supplemented where possible with hard data.

A study of Gorky, of the sort called for by Rubin, appeared in 1963, and was written by Rubin himself. The historical weight in his writing is clearly detected in the following.

> . . . this unanimity as to the quality of Gorky's art is in marked contrast to the divergence of opinion on the nature of his style and its historical position in the critical decade of the 1940's; or, more specifically, his possible role either as the last Surrealist or as a pioneer of the new American painting.[31]

While it is not my intention here to capsulate Rubin's thesis, the following passage indicates the dramatically different texture of his writing from criticism of the forties and the earlier fifties.

> It may be, however, that the unique affinity to Miró in the latter picture was catalyzed by a very particular event: the first Retrospective Exhibition of Miró in New York, held at the Museum of Modern Art in 1941. There Gorky could observe in detail Miró's conversion from Cubism to Surrealism. Among the Pictures included were the *Tilled Field*, and one other which I believe may have left a particular im-

pression on the *Garden in Sochi,* we would possess a new *terminus ante quem* for the execution of the picture, a date no earlier than 1941.[32]

Other examples of this history are not hard to find and appear with particular strength following the Los Angeles exhibition mounted by Maurice Tuchman in 1965.[33]

Also concerned with setting the record straight is Irving Sandler, who, viewing the movement as an historical period, wants to ". . . attempt to reconstruct what actually happened."[34]

> For nostalgia-prone artists who frequented the Waldorf Cafeteria, the lectures on the "Subjects of the Artist" School and Studio 35, the Club and the Cedar Street Tavern, the decade following the Second World War was 'the good old days.' . . . For others— the careerists—the social history of Abstract Expressionism, once it became important, has been something to rewrite. With an eye to future position, they have tried to change the past. Both attitudes (aggravated by natural lapses of memory) have led to myth-making, which, like any distortion of past events, saps them of authenticity.[35]

What then follows is a description of this abstract expressionists' social activity, based, in as much as that is possible, on the evidence of "hard" data. "The Surrealist Emigrés in New York," also by Sandler, can serve as another illustration of this trend and emphasizes the same scrupulousness in dealing with the facts.[36] In a careful description of the social and intellectual ambience of New York in the forties, Sandler separates himself from the polemical and highly metaphorical view of Paris given us by Rosenberg in "The Fall of Paris" (1940). The most complete historical document of this nature is Sandler's own *Triumph of American Painting* where he attempts to set the whole record straight.[37] Unlike Rubin and others, however, Sandler is an historian without a problem. The book is useful inasmuch as it puts the data all under one cover, but there is very little in his overall point of view that is new. His historical framework of depression, Surrealism, "gesture painters," and "color-field painters" is typical of the predictable categories of his thinking. A comment related to this author by one of the earlier critics seems appropriate. It is an attempt to let the surviving members of the group write their own history.

The tendency of these recent writers to stress the social and community aspects of Abstract Expressionism is no accident and may reflect more than historical objectivity. As Sandler has pointed out, "of all the subjects discussed, the one that recurred most often and that created the hottest controversy was the problem of community, of defining shared ideas, interests and inclinations."[38]

> Club members supposed that their peers understood how a picture "worked" in formal terms. Therefore, they tended to talk about the function of art, the nature

of the artist's moral commitment and his existentialism. . . . This created frustrating
difficulties, because such ideas can rarely be checked against specific works.[39]

This attitude, witnessed here among artists, goes far, I believe, towards rein-
forcing some of the premises which have governed the present thesis; that
is, that the critics were generally no more interested in introducing specific
works into their discussions than the artists themselves.

The controversy over the philosophy and function of criticism, already
discussed in relation to the forties, and epitomized in the running debate be-
tween Greenberg and Rosenberg, continued to occupy various critics through
the sixties. And, for all the changes in styles, and the neglect of the abstract ex-
pressionist painters in the critical literature, discussions centering on the philo-
sophy of criticism in the sixties can almost without exception be traced back to
problems of the forties and fifties. If there was anything new about these discus-
sions during the sixties, it was a new infusion of philosophical consciousness into
the problem.

In "The Politics of Art, Part I," Barbara Rose uses Michael Fried, a
claimant to the tradition of Wittgenstein *(Art Criticism of the Sixties)*, and a
close disciple of Greenberg whose experience with the senior critic included a
post-graduate seminar at Harvard, as a means of restating the familiar historical
dichotomy.

> Fried explains that this desperation depends on the conviction that . . . the terms in
> which certain painters are described and certain accomplishments held up for admira-
> tion are blind, misleading, and above all *irrelevant* to the work itself and to the
> difficult, particular enterprise by which it was created.[40]

> Obviously I view Mr. Fried's charge of ideology and his own exclusive position as
> quite dangerous to any kind of appraisal of art. I feel that the sense of outrage he
> experiences when he reads contemporary criticism is both disproportionate, and
> misplaced . . .[41]

Finally, and somewhat in the spirit of the historian-critic, Rose calls, (at least
implicitly), for a relativistic appraisal of criticism.

> Already a synthetic criticism, which has no vested interest in ignoring subject
> matter or subject content, is being practiced by a small group of art historians in-
> cluding William Rubin, Robert Rosenblum, and Leo Steinberg . . .[42]

In an exchange between Sonya Rudikoff and Irving Sandler, published in
Arts of 1960, the same polarities just described above are reduced to the ques-
tion of what ontological claims must or can be preserved, both from the point of
view of the language used in criticism and the object addressed in criticism.
Rudikoff is concerned over a criticism which she feels has lost the object.

> The back cover of it (*School of New York: Some Younger Artists,* ed. by B.H. Fried-
> man) speaks of the 'exciting language' in which the eleven pieces are written to
> accompany the 'exciting' work. Possibly there's the trouble I'm thinking of–the
> fact, everywhere observable, that contemporary writing on art often appears too
> excited and exciting, even manic. And in the process it loses its object.[43]

Echoing Goldwater almost to the letter, Rudikoff continues:

> Inevitably there are difficulties whenever insights become received ideas. But there is
> a further difficulty when the discussion of painting focuses too much on the act of
> painting . . . Writers on art are highly sophisticated in their interpretive identifications
> with the art of painting, but the psychology is mostly bad and uninformed and it
> implies a discussion of the painter, not the painting, of attitudes, of manner, of
> style.[44]

Rudikoff does want criticism to turn on actuality, but not merely to identify
it. "I'm not proposing any rule or method, perhaps nothing but a more pro-
found exploration of the way things have meaning beyond themselves, and how
one responds to this."[45]

In his reply, Mr. Sandler suggests ". . . that any idea suggested by the work
of art–aesthetic, historical, metaphysical, psychological, the way paintings take
form or their impact on us–may be used if it helps elucidate a picture and can
be checked against the work."[46] As for Rosenberg's concern over "action":

> A concern with 'action' need not 'obscure the object,' if the object itself forces
> attention to its taking form as part of its meaning. . . . It is by comparing pictures
> that their frames of reference, intentions, organizing values and the other elements in
> their complex of meanings emerge.[47]

Miss Rudikoff objects, no doubt, on the grounds that this would compromise
the "actuality" of the painting and, in her reply, says the following:

> The problem for critics is not to 'find ways of talking about action.' This is just what
> seems wrong.[48]

> Even if all previous norms, meanings, circumstances, intentions of art are questioned
> or overthrown, and all that remains is medium and the act of painting, it is still neces-
> sary to write about what the picture does, not how the painter acts. Obviously the
> action must be inferred, assumed, understood in all its resonance, especially when it
> has new aspects or intentions; but this goes without saying.[49]

The evaluations of individual critics, then, become more numerous in the
sixties and reflect, by and large, the success of the Greenbergian approach in the
"post-painterly" period following Abstract Expressionism. Almost without
exception, however, they are written as specific applications (or invectives) of

the larger issues contained in the Rosenberg-Greenberg dispute, and from the point of view of one who is trying to settle the dispute rather than to appraise it historically. Since this is the case, a single example of this sort of literature will suffice for present purposes.

Amy Goldin serves as an example of the camp of critics hostile to the Rosenberg position.

> . . . He and Malraux are both literary men who developed against a background of leftist political engagement. Both of them retain a nostalgia for sweeping moral visions of culture. . . . They both seem to think metaphorically, and to 'read' art as an expression of something else that validates it, something more real than it is, social development or culture. The result is a fantastic sentimentalization of art.[50]

She then goes on to criticize Rosenberg for the very idea which, in the opinion of this author, distinguishes his criticism; this idea is the behavioral basis of the acquisition of meaning.

> Involvement with the painting-as-art-object is a danger for the artist; and for the spectator it is fatal. Attention to what Rosenberg calls its 'esthetic qualities'—its line, color, texture—identifies it as art and detaches it from the life of action, thus robbing it of the possibility of *meaning* anything important.[51] (emphasis mine)

The fact that Goldin is "choosing sides" or polemicizing from "the inside" is reaffirmed in her conclusion.

> His refusal to distinguish between theoretical and rhetorical effectiveness is not petty self-indulgence. It is the denial of the function of intelligence and a refusal to be fully present.[52]

The implicit approval of Greenberg can hardly be mistaken.

Toward a History of Criticism

In the sixties critics finally began putting earlier critics and their writing into an historical perspective. Understood in terms of *why* it said what it did, criticism of the forties and fifties then became viewed as part of the history of criticism.

In this final section, it is fitting to look at two brief statements written on the history of abstract expressionist criticism. They will serve the dual purpose of providing a basis for evaluating my own conclusions, but perhaps, more importantly, of historically resolving this critical development of two decades standing. The two statements I refer to are "Greenberg and the Group: A Retrospective View," by Barbara Reise,[1] a young critic, presently working in England, and "The Critical Reception of Abstract Expressionism," by Max Kozloff.[2]

Like Goldin, Reise is still embedded in a struggle with the older criticism, but not so much with the older critics themselves, whose contribution she wishes to recognize, as their younger disciples—especially Greenberg's. Criticism, for Reise, divides itself into two camps which might be characterized as criticism "from the inside," of which Rosenberg is the main exponent, and "criticism from the outside," practiced best by Greenberg. Thus, her description of Rosenberg.

> . . . As a practicing poet writing to a private and sympathetic audience, his style was metaphoric rather than didactic, and he was naturally concerned more with the character and context of the creative act than its resulting pictorial form. Writing of a shared experience, Rosenberg was little help to more prosaic souls outside that experience; he was no help to critics wanting to evaluate the paintings as objects in galleries; and it is hardly surprising that his important essay on 'The American Action Painters' has been universally misunderstood and reduced to a label for thrown paint.[3]

In contrast to the closed, elite audience addressed by Rosenberg, the audience of Greenberg's criticism was more broadly conceived. According to Reise, this can best be accounted for by his contact with *Partisan Review* (as editor from 1941-43) whereupon

> . . . years later, sure that academic art-history and belles-lettres criticism were hopelessly retardataire, he asserted that 'It belongs to journalism . . . that each new phase

of modernist art should be hailed as a start of a whole new epoch in art, marking a decisive break with the past. [4]

Also in contrast to Rosenberg's poetic and metaphorical criticism, Greenberg offered a more didactic, attainable kind of system which naturally attracted a wider audience.

> . . . But Greenberg's didactic prose, references to the history of modern art, and analyses of formal properties of exhibited art made his ideas more accessible to critics and the countless art-history and painting students who discovered Abstract Expressionism in the late 'fifties. With the 1961 publication of his collected and smoothly re-written essays and his continued interest in the latest things shown in galleries, Greenberg's stature to the newly-arrived was truly monumental. [5]

For these reasons, it was Greenberg that dominated criticism in the late fifties and sixties (especially upon the publication of *Art and Culture*). Reise notes that about this time, Greenberg's position ". . . became more didactic, concerned with philosophy and history, removed from concrete aesthetic encounters, and seemingly sure of its own objectivity . . ." and this for two reasons: 1) ". . . the threat to his taste and critical assumptions in the success of Pop art," and 2) the contact he had with the art-history establishment. [6] Reise ended her appraisal of Greenberg and his disciples by deploring the forced vision of history that his critical system commits him to, a subject discussed so well elsewhere that it need not be elaborated here. Like many other critics, she notes that the "net result warps contemporary art to the shape of its own inflexible form." [7] Her pronouncements on the intellectual parentage of Greenberg's criticism are not very helpful; ". . . it is influenced by Marx, later dominated by Wölfflin, and thus tied to pre-Darwinian thought and to Hegel." [8] According to Reise, Greenberg's studies of Marx, Hegel and Wölfflin were subsequently reshaped by updated versions of Wölfflin via his contact with Harvard "section leaders" (Fried, Krauss, and Cone) between 1961 and 1963. [9]

Although Reise is certainly correct in many respects, certain points of emphasis seem to me to be misplaced and unhistorical. A certain lack of realism in Reise's account, a condition which seems endemic to a European view of the American scene, may be partially reflected by her geographic removal. Otherwise, this rests, I believe, on what she unreasonably expects from all critics, in whatever situation they happen to find themselves in, a point already discussed with regard to Goldwater and others in an earlier chapter. Collingwood's claim that history is what historians write and not "how it really was" comes to mind. It seems to me that this could be maintained with equal validity for critics, and leaves open the question of *why* they wrote what they did. Whether one likes it or not, the criticism was written and it is unhistorical to deplore the quality of the criticism from that point of view alone. The historian wants to explain

why it was written in such a way. He is interested, not in the justification of such a criticism, but in the reasons which account for its existence. The critics of the forties perceived that the success of the movement did not rest on the successful appreciation of the art object so much as it did on the validation of the movement in official terms of progress, newness, inevitability, or continuity with the history of art. It was recognition rather than edification which seemed to offer these critics, and the artists for which they were spokesmen, the most potential for tangible rewards.

Kozloff, for his part, recognizes some of the problems inevitably encountered in a history of recent criticism and asks "what kind of enduring companionship between art and criticism has resulted from the gallons of ink spilled.?"[10] Unlike Reise, Kozloff sees the two major positions evolving, not from "inside" and "outside," the community, but in response to two different directions in the paintings it was addressing. He groups these polarities in painting around Pollock and Newman.[11] While I think the criticism can be construed in this manner, I doubt that it explains why criticism emerged the way it did. As Kozloff himself says of Greenberg ". . . his own expectations were remarkably unsuited to evaluating the phenomenon with which his name is associated. . .,"[12] a curious state of affairs if his theory was actually derived from the art. More to the point is the following passage.

> Some of the polemics which arose, as much with us now as then, have to do with the work of art of self expression, and as vehicle of historical consciousness; the nature of aesthetic crisis and moral content in art; and finally, overarchingly, the function and identity of criticism itself.[13]

It is in all this that Kozloff finds much in common between Greenberg and Rosenberg, a point that he feels has been neglected in the literature. Both, according to him, espouse the notion of art as a "form of self-discovery and revelation."[14] That he is thinking in communal as well as individual terms is clear from the following.

> In retrospect, it can be seen how necessary this was in an atmosphere where the precedents were overwhelmingly European, and where the nascent identity of a number of American artists was in a fragile and uncertain state.[15]

Further, both critics were sensitive to the underdog status of the American avant-garde ". . . which enlisted the support and confirmed the dogma of politically oriented critics who could transfer their earlier left-wing dialectics to an embattled aesthetic minority."[16] Finally, both depend on some notion of "crisis"; with Greenberg, the imminent triumph of kitsch, and with Rosenberg, the threatening political situation.[17]

On a deeper level, 'crisis' was the most fitting expression of Greenberg's evolving concept of the contemporary painter's problematical relation with the tradition of modern art.[18]

Such an interpretation of Greenberg does seem correct and seems to represent a vertical version of "crisis" expounded by Rosenberg in *The Anxious Object*. As in Reise's article, little attention is paid to the sources for this criticism except for stressing the importance of Hofmann for Greenberg, a fact which Greenberg himself has spoken of in print.[19] As for Rosenberg,

Rosenberg, whose interests are as much literary as artistic, seems to arrive at his theory of painting by grafting together ideas from Sartre, something of Dada, and more conventional Expressionist notions of empathy.[20]

Hess is mentioned as the third of the important early critics, where an attempt was made "to identify and legitimize Abstract Expressionism as part of its great European past," and this largely by providing it with an iconography of landscape and cityscape, what Kozloff calls "qualities of environment."[21] "He [Hess] concludes with Picasso, that there is no such thing as abstract art, and agrees with Rosenberg in his fundamental conception of criticism."[22] It is clear, however, that Kozloff, despite his relativistic awareness of criticism, is not completely ready to relinquish idealistic aesthetics. And Kozloff, in perhaps the most catholic essay on the critics to date, thus ends on the same idealisistic assumptions which, in my opinion, have so far prevented a real history of the movement.

In all recent evaluations of abstract-expressionist criticism there is an unmistakable implication that there is one proper and necessary way for criticism to proceed. This naturally entails the belief that criticism submits, more or less, to definition. Once it is agreed upon what criticism is, and what it logically requires from that, the critic is held responsible for these points in his performance. It is from such a definitional point that abstract expressionist criticism has been approached. If, on the other hand, it is true that the so-called critic was trying to do something quite outside the role of traditional criticism, the recent counter-criticism (which is really a critic's version of the philosophy of criticism) is irrelevant. The question then becomes, what were these "critics" trying to do, and why were they trying to do it. With this shift in questions, the complexion of the problem changes from a primarily philosophical one to an historical one.

In an effort to clear the way for such a history, and to indicate the directions it might take, I have been especially concerned to show that the work of art did not necessarily have a prescriptive relationship to the criticism it accompanied. Indeed, considering the vastness of any cross-section of modern art in

the forties and fifties, the critic, before he entered into the critic's role as classically defined, had to select something from this cross section as the object of his criticism. The selection already rested, at that point, on the guiding premises of his criticism. That the critics' strategies frequently outlasted the style they were nominally designed to discuss only underscores the truth of this fact. The particular art that the critic chose was seen by him as more or less amenable to the premises he already possessed. These fundamental premises were frequently located in the history of criticism and often depended for their newsness on the new historical context in which they found themselves applied. Understandably, many ideas were borrowed precisely because of their effectiveness in the past.

It must be stressed, however, that the critic in mid-century America did not divorce or withdraw his criticism from the object. His task was to insure its success. In the situation then prevailing the critic was most anxious to present this art as a broadly based reaction to, or continuation of, earlier modernist painting. Since such a broad base could not be achieved pictorially, the critical strategies often depended, as in the case of Greenberg and Rosenberg, on an historically or ethically prescribed communality.

If this criticism must be judged, it should, like art itself, be judged in accordance to the goals it set itself. Given the controversy generated, the success of the artists it described, and its influence on contemporary criticism, the success of abstract expressionist criticism can hardly be doubted.

Notes

Preface

1. Sidney Janis, introduction to "Mark Rothko," *Art of This Century Gallery* (Jan. 9-Feb. 4, 1945), n.p.

2. Robert Coates, "Assorted Moderns," *New Yorker,* vol. 20, no. 4 (Dec. 3, 1944), p. 51.

3. Howard Putzel, "A Problem for Critics," statement accompanying an exhibition of the same title, printed in *The New York Times,* July 1, 1945, sec. 2, p. 2.

4. Clement Greenberg, "Art," *The Nation,* vol. 163, no. 2 (July 13, 1946), p. 54.

Chapter 1

1. Milton Brown, *American Painting from the Armory Show to the Depression* (Princeton: Princeton University Press, 1970), p. 94.

2. Rudi Blesh, *Modern Art, U.S.A.* (New York: Alfred A. Knopf, 1956), pp. 139-40.

3. Thomas Craven, "Nationalism in Art," *Forum and Century,* vol. 45, no. 6 (June, 1936), p. 359.

4. Ibid.

5. Donald D. Egbert, *Socialism and American Art* (Princeton: Princeton University Press, 1967), p. 90.

6. Harold Rosenberg, "The Art World: The Profession of Art," *New Yorker,* vol. 45, no. 15 (June 3, 1972), p. 87.

7. Harold Rosenberg, *Arshile Gorky* (New York: Horizon Press, 1962), pp. 84-85.

8. Harold Rosenberg, *The De–definition of Art* (New York: Horizon Press, 1972), p. 185.

9. Rosenberg, *Arshile Gorky,* p. 88.

10. Meyer Schapiro, "The Social Basis of Art," *First American Artists' Congress,* (New York, 1936).

11. Ibid., p. 31.

12. Schapiro, Meyer, "Nature of Abstract Art," *Marxist Quarterly*, vol. 1, no. 1 (Jan.-Mar., 1937), p. 78.

13. Clive Bell, "Art in the Planned State," *Forum and Century*, vol. 47, no. 5 (May, 1937), pp. 306-07.

14. Ibid., p. 309.

15. Duncan Phillips, "Personality in Art," *Magazine of Art*, vol. 28, no. 2 (Feb., 1935); vol. 28, no. 3 (Mar. 1955).

16. Rosenberg, "The Art World . . . ," p. 88.

17. Ibid., p. 85.

18. Rosenberg, *Arshile Gorky*, p. 83.

19. Michael Fried, "Marxism and Criticism," *Arts Magazine*, vol. 36, no. 4 (Jan., 1962), p. 71.

Chapter 2

1. Samuel Kootz, Letter to *The New York Times*, printed in "The Problem of Seeing," by E.A. Jewell, *The New York Times* (Aug. 10, 1941), sec. 9, p. 7.

2. Samuel Kootz, *New Frontiers in American Painting* (New York: Hastings House, 1943), p. 60.

3. Ibid., p. 56.

4. Irving Sandler, *The Triumph of American Painting* (New York: Praeger, 1970), p. 2.

5. Holgr Cahill, *New Horizons in American Art* (New York: Museum of Modern Art, 1936).

6. Kootz, op. cit., p. 6.

7. Ibid., p. 8.

8. Ibid., p. 62.

9. Ibid., p. 15.

10. Ibid., p. 3.

11. Ibid., p. 7.

12. "Document," *Art Digest*, vol. 28, no. 4 (Nov. 15, 1953), p. 4.

13. Dr. Grace Morely of the San Francisco Museum of Art mounted an exhibition coinciding

with the publication of Janis' book. The contents of the show were based on Janis' illustrations.

14. Sidney Janis, *Abstract and Surrealist Art in America* (New York: Renal and Hitchcock, 1944), pp. 50-51.

15. Ibid., p. 89.

16. Ibid., p. 52.

17. Ibid.

18. Ibid., p. 87.

19. Ibid., p. 127.

20. H.H. Arnason, *Abstract Expressionists and Imagists* (New York: The Solomon R. Guggenheim Museum, 1961), p. 13.

21. Janis, op. cit., p. 50.

Chapter 3

1. Clement Greenberg, "The Renaissance of the Little Mag." *Partisan Review,* vol. 8, no. 1 (Jan.-Feb., 1941), pp. 75-76.

2. Ibid., p. 73.

3. Ibid., p. 76.

4. Clement Greenberg, "Ten Propositions on the War," *Partisan Review,* vol. 8, no. 4 (Jul.-Aug., 1941), p. 271.

5. Ibid.

6. Clement Greenberg, "Towards a Newer Laocoon," *Partisan Review,* vol. 7, no. 4 (July-Aug., 1940), p. 305.

7. Clement Greenberg, "Avant-garde and Kitsch," in *Art and Culture* (Boston: Beacon Press, 1968), p. 11.

8. Ibid.

9. Clement Greenberg, "Towards a Newer Laocoon," p. 297.

10. Ibid., p. 301.

11. Renato Poggioli, *The Theory of the Avant-garde* (New York: Harper & Row, 1971), p. 80.

12. Hans Hofmann, "Painting and Culture," in *Search for the Real* (Cambridge: M.I.T. Press, 1967), p. 57.

13. Clement Greenberg, "New York Painting Only Yesterday," *Art News,* vol. 56, no. 4 (Summer, 1966), pp. 59, 85.

14. Wassily Kandinsky, *Concerning the Spiritual in Art* (New York: George Wittenborn, 1966), p. 39.

15. Clement Greenberg, "Towards a Newer Laocoon," p. 304.

16. Kandinsky, op. cit., p. 39.

17. Ibid., pp. 39-40.

18. Clement Greenberg, "The Present Prospects of American Painting and Sculpture," *Horizon* (London), vol. 16, nos. 93-94 (Oct., 1947), pp. 20-30.

19. Ibid., pp. 22-23.

20. Ibid., p. 20.

21. Ibid., p. 23.

22. Ibid., p. 24.

23. Ibid., p. 26.

24. Ibid.

25. Ibid.

26. Ibid., p. 29.

27. Ibid., p. 27.

28. Ibid.

29. Clement Greenberg, "The Situation at the Moment," *Partisan Review,* vol. 15, no. 1 (Jan., 1948), p. 84.

30. Ibid., p. 82.

31. Ibid., pp. 83-84.

32. Ibid., pp. 81-82.

33. Ibid., pp. 83-84.

34. Clement Greenberg, "A Symposium . . .," *Magazine of Art,* vol. 42, no. 3 (March, 1949), p. 92.

35. Ibid.

36. Ibid.

37. Nicolas Calas, "The Enterprise of Criticism," in *Art in the Age of Risk* (New York: E.P. Dutton & Co., 1968), pp. 139-40.

38. Ibid., pp. 140-41.

39. Walter Pater, *The Renaissance* (New York: The New American Library, 1959), p. 142.

40. Ibid., p. 143.

41. Ibid., p. 95.

42. Ibid., p. 98.

43. Quoted in Wylie Sypher, *Rococo to Cubism in Art and Literature* (New York: Vintage, 1960), p. 172.

44. Ibid., p. 195.

45. Ibid., p. 221.

46. Ibid., pp. 223-24.

47. Ibid., p. 268.

48. Lionello Venturi, *History of Art Criticism* (New York: Dutton, 1964), p. 298.

49. D.H. Kahnweiler, "Mallarmé and Painting," rpt. in Marcel Raymond's *From Baudelaire to Surrealism* (New York: Wittenborn, 1949), p. 363.

50. Ibid., p. 360.

51. Robert Motherwell, Prefatory note to Marcel Raymond's *From Baudelaire to Surrealism,* n.p.

52. Sypher, op. cit., p. 248.

53. Clement Greenberg, "T.S. Eliot: A Book Review," in Clement Greenberg's *Art and Culture* (Boston: Beacon Press), p. 239.

54. Ibid.

55. Ibid., p. 240.

Chapter 4

1. Harold Rosenberg, "The Front," *Partisan Review,* vol. 2, no. 6 (Jan.-Feb., 1935), p. 75.

2. Harold Rosenberg, "The Unlearning," *Partisan Review,* vol. 2, no. 5 (1940), pp. 354-55.

3. Harold Rosenberg, "The Fall of Paris," in *The Tradition of the New* (New York: McGraw-Hill, 1960), p. 213.

4. Ibid., p. 216.

5. Ibid., p. 218.

6. Ibid., p. 219.

7. Harold Rosenberg, "The Resurrected Romans," *The Kenyon Review,* vol. 4, no. 4 (Autumn, 1948), p. 602.

8. Ibid., pp. 617-18.

9. Harold Rosenberg, "Introduction to Six American Artists," *Possibilities I* (Winter, 1947-48), p. 75.

10. Ibid.

11. Ibid.

12. Harold Rosenberg, "The American Action Painters," *Art News,* vol. 51, no. 8 (Dec. 1952), pp. 22-23.

13. R. Motherwell and H. Rosenberg, "Statement," *Possibilities I* (Winter, 1947-48), p. 1.

14. Motherwell and Rosenberg, op. cit., p. 1.

15. Ibid.

16. Harold Rosenberg, *Arshile Gorky* (New York: Horizon Press, 1962), pp. 92-94.

17. Harold Rosenberg, "Death on the Wilderness," in *The Tradition of the New* (New York: McGraw-Hill, 1960), p. 251.

18. René Welleck, *Concepts of Criticism* (New Haven: Yale University Press, 1967), pp. 361-62.

19. Harold Rosenberg, Introduction to Marcel Raymond's *From Baudelaire to Surrealism* (New York: Wittenborn, 1949), p. xi.

20. Ibid.

21. Alfred Barr, *Fantastic Art, Dada, Surrealism* (New York: Museum of Modern Art, 1936), p. 15.

22. Max Kozloff, "An Interview with Robert Motherwell," *Artforum,* vol. 4, no. 1 (Sept., 1965), p. 37.

23. Richard Huelsenbeck, "En Avant Dada," in *Possibilities I* (Winter 1947-48), p. 42.

24. Ibid., p. 43.

25. Marcel Raymond, *From Baudelaire to Surrealism* (New York: Wittenborn, 1949), p. 154.

26. Alfred Barr, op. cit., pp. 29-30.

27. Harold Rosenberg, Introduction to Marcel Raymond . . ., p. xii.

28. Ibid., p. xiv.

29. William Carlos Williams, "The American Background," in *America and Alfred Stieglitz* (New York: Doubleday, Doran & Co., 1934), pp. 14-15.

30. Harold Rosenberg, "Parable of American Painting," in *Tradition of the New* (New York: McGraw-Hill, 1965), p. 18.

31. Ibid., p. 19.

32. Harold Rosenberg, "Introduction to Six American Artists," op. cit., p. 75.

33. Jacques Barzun, *Classic, Romantic and Modern* (New York: Anchor Books, 1961), p. 153.

34. Clement Greenberg, "A Symposium . . .," *Magazine of Art,* vol. 42, no. 3 (March, 1949), p. 92.

35. Harold Rosenberg, "The Shapes in a Baziotes Canvas," *Possibilities I* (1947-48), p. 2.

36. Ibid.

37. Clement Greenberg, "Art," *The Nation,* vol. 168, no. 9 (Feb. 19, 1949), p. 221.

38. Ibid.

Chapter 5

1. James Thrall Soby, "Some Younger American Painters," in *Contemporary Painters* (New York: Museum of Modern Art, 1948), pp. 69-84.

2. Ibid., p. 79.

3. Ibid., p. 79.

4. Ibid., p. 79.

5. Ibid., p. 74.

6. Ibid., pp. 75-78.

7. Ibid., p. 69.

8. Denys Sutton, "The Challenge of American Art," *Horizon* (London), vol. 20, no. 118 (Oct., 1949), p. 282.

9. Ibid., p. 283.

10. Ibid., p. 279.

11. Ibid., p. 281.

12. Ibid., p. 277.

13. Ibid., p. 281.

14. Ibid., p. 284.

15. Henry James, "Criticism" (orig. in *Essays in London and Elsewhere*) in *The Tiger's Eye,* vol. 1, no. 1 (Oct., 1947), p. 36 f.

16. "Pollock," *Art News,* vol. 45, no. 3 (May, 1946), p. 63.

17. Jules Lansford, "Baziotes in Solo Show," *Art Digest,* vol. 22, no. 10 (Feb. 15, 1948), p. 21.

18. Maude Riley, "Jackson Pollock," *Art Digest,* vol. 19, no. 13 (Apr. 1, 1945), p. 59.

19. Ibid.

20. Ibid.

21. "A Symposium: The State of American Art," *Magazine of Art,* vol. 42, no. 3 (March, 1949), pp. 83-102.

22. Alfred Barr, "A Symposium. . .," p. 85.

23. Douglas MacAgy, "A Symposium . . .," p. 94.

24. Ibid., p. 95.

25. Russell Davenport, "A *Life* Roundtable on Modern Art," *Life,* vol. 25, no. 15 (Oct. 11, 1948), pp. 56-79.

26. Douglas MacAgy, "Western Roundtable on Modern Art." Ed. version in *Modern Artists in America,* ed. by Reinhardt and Motherwell (New York: Wittenborn, 1951), pp. 25-38.

27. Robert Motherwell, "The Modern Painter's World," *Dyn,* no. 6 (Nov., 1944), p. 12.

28. Ibid., p. 13.

29. Ibid.

30. Irving Sandler, *The Triumph of American Painting* (New York: Praeger, 1970), p. 37-38, 41.

31. Motherwell, op. cit., p. 13.

32. Harold Rosenberg, "Introduction to Six American Artists," *Possibilities I* (Winter, 1947-48).

33. Harold Rosenberg, "The American Action Painters," *Art News,* vol. 5, no. 8 (Dec., 1952), pp. 22-23.

34. Adolf Gottlieb, "The Ides of Art," *The Tiger's Eye,* no. 2 (Dec., 1947), p. 43.

35. Jackson Pollock, "My Painting . . .," *Possibilities I* (Winter, 1947-48), p. 75.

36. Mark Rothko, "The Romantics Were Prompted . . .," *Possibilities I* (Winter, 1947-48), p. 84.

37. Harold Rosenberg, "The Teaching of Hans Hofmann," *Arts Magazine,* vol. 45, no. 3 (Dec.-Jan., 1971), p. 176.

38. Hans Hofmann, "The Search for the Real in the Visual Arts," in *Search for the Real and Other Essays,* (Cambridge: M.I.T. Press, 1968), p. 40.

39. Barnett Newman, "The First Man Was An Artist," *The Tiger's Eye,* no. 1 (Oct., 1947), pp. 58-59.

40. Ibid., p. 59.

41. Ibid., p. 60.

42. Irving Sandler, op. cit., pp. 62-69; 70 fn. 5.

43. Ibid.

44. Wolfgang Paalen, "Introduction," *Dyn,* no. 4-5 (Spring, 1944), n.p.

45. Parker Tyler, Review of *Possibilities* and *The Tiger's Eye, Magazine of Art,* vol. 41, no. 3 (March, 1948), p. 109.

46. Ibid.

47. Ibid., pp. 109-110.

Chapter 6

1. Joseph Margolis, "The Logic of Interpretation," in *Philosophy Looks at the Arts,* ed. by Margolis (New York: Charles Scribner's Sons, 1962), p. 110.

2. Ibid., p. 111.

3. Ibid., p. 113.

4. Ibid., p. 111.

5. Robert Goldwater, "Varieties of Critical Experience," *Artforum,* vol. 6, no. 1 (Sept., 1967), p. 40.

6. Ibid.

7. Ibid.

8. Ibid., p. 41.

9. B.H. Friedman, *The School of New York: Some Younger Artists* (New York: Grove Press, 1959), p. 7.

10. Blaise Cendrars, "Pourquoi le 'Cube' s'effrite," *La Rose Rouge,* no. 3, 1919, rpt. in *Cubism* by Edward Fry (New York: McGraw-Hill, 1966), p. 154-56.

11. Leonce Rosenberg, "Cubisme et Tradition," *Valori Plastici,* Rome, 1919, rpt. in *Cubism* by Edward Fry (New York: McGraw-Hill, 1966), p. 150.

12. Renato Poggioli, *The Theory of the Avant-garde* (New York: Harper and Row, 1971), pp. 149-50.

13. Maurice Tuchman (ed.) *New York School—The First Generation* (Los Angeles, Los Angeles County Museum, 1965).

14. *Contemporary American Painting and Sculpture* (Urbana, University of Illinois Press, 1948).

15. *Contemporary American Painting and Sculpture,* 1951.

16. *Contemporary American Painting and Sculpture,* 1955.

17. Dorothy Miller (ed.), *Fourteen Americans* (New York: The Museum of Modern Art, 1946).

18. Dorothy Miller (ed.), *Fifteen Americans* (New York: The Museum of Modern Art, 1952).

19. R. Motherwell and A. Reinhardt (eds.) *Modern Artists in America* (New York: Wittenborn Schultz, Inc., 1952).

20. Thomas B. Hess, "The New York Salon," *Art News,* vol. 52, no. 10 (Feb., 1954), pp. 24-25, 56-57.

21. H. Motherwell and A. Reinhardt, op. cit., p. 40.

22. John Golding, *Cubism* (Boston: Boston Book and Art Shop, 1968), p. 26.

23. Guillaume Apollinaire, "Les Indépendants, Cercle d'Art, 8me Salon," 1911. Cited in Golding, *Cubism,* op. cit., p. 25.

24. Oliver-Hourcade, *Paris Journal,* 1912. Cited in Golding, *Cubism,* op. cit., p. 27.

25. Guillaume Apollinaire, *Les Peintres Cubistes.* Paris, 1913. Cited in Golding, *Cubism,* op. cit., p. 34.

26. Guillaume Apolinaire, "Du Sujet dan la Peinture Moderne," in *Les Peintres Cubistes.* Paris, 1913. Cited in Golding, *Cubism,* op. cit., pp. 35-36.

27. Poggioli, op. cit., pp. 150-51.

28. André Breton, "The Eye Spring of Arshile Gorky," forward to an exhib. catalogue, rpt. in *It Is,* 4 (1959), p. 57.

29. Ibid.

30. Ibid.

31. Clement Greenberg, "Art," *The Nation,* vol. 160, no. 12 (March, 1945), pp. 342-43.

32. Ibid.

33. Ibid.

34. Ibid.

35. Clement Greenberg, "Art," *The Nation,* vol. 162, no. 18 (1946), pp. 552-53.

36. Ibid., p. 553.

37. Harold Rosenberg, *Arshile Gorky* (New York: Horizon Press, 1962), p. 94.

38. Ibid., p. 95.

39. Ibid., p. 101.

40. Ibid., p. 74.

41. Ibid., p. 118.

Chapter 7

1. Clement Greenberg, "Art," *The Nation,* vol. 168, no. 24 (June 11, 1949), p. 669.

2. Ibid.

3. Ibid.

4. Ibid.

5. Clement Greenberg, "The European View of American Art," *The Nation* (Nov. 25, 1950), p. 490.

6. David Sylvester, "Mrs. Sylvester Replies," *The Nation* (Nov. 25, 1950), p. 492.

7. Ibid.

8. Ibid., p. 493.

9. Ibid.

10. Patrick Heron, "The American at the Tate Gallery," *Arts,* vol. 30, no. 6 (March, 1956), p. 11.

11. Ralston Crawford, "Is the French Avant-garde Overrated?," *Art Digest,* vol. 27, no. 20 (Sept. 15, 1953), p. 12.

12. Robert Motherwell, "Is the French Avant-garde Overrated?," p. 13, 27.

13. Clement Greenberg, "Is the French Avant-garde Overrated?," p. 12.

14. Irving Sandler, *The Triumph of American Painting* (New York: Praeger, 1970), p. 213.

15. Ibid.

16. Alfred Frankfurter, "Blind Justice," *Art News,* vol. 49, no. 4 (Summer, 1950), p. 15.

17. A. Reinhardt and R. Motherwell (eds.), *Modern Artists in America* (New York: Wittenborn, Schultz, 1951).

18. April 21-23, 1950.

19. April 8-10, 1949.

20. Appeared originally in *Art d'aujourd'hui,* June, 1951 in a special issue called "Painting in the United States."

21. Reinhardt and Motherwell, op. cit., p. 40.

22. Thomas B. Hess, "The New York Salon," *Art News,* vol. 52, no. 10 (Feb., 1954), pp. 56-57.

23. Ibid., p. 57.

24. Sandler, op. cit., p. 214.

25. Irving Sandler, "The Club," *Artforum,* vol. 4, no. 1 (Sept., 1965), p. 30.

26. Thomas B. Hess, *Abstract Painting: Background and American Phase* (New York: Viking Press, 1951).

27. Andrew Ritchie, *Abstract Painting and Sculpture in America* (New York: The Museum of Modern Art, 1951).

28. Thomas B. Hess, *Abstract Painting,* . . . p. 158.

29. Ibid., p. 4.

30. Ibid. p. 91.

31. Ibid., p. 99-100.

32. Ibid., p. 100.

33. Ibid.

34. Philip Pavia, "Advice to Future Polemicists," *It Is,* no. 5 (Spring, 1960), p. 84.

35. Ritchie, op. cit., p. 99.

36. Ibid., p. 66.

37. Ritchie, op. cit., p. 66.

38. Ibid.

39. Ibid., p. 125.

40. Ibid., p. 102.

41. Adolf Gottlieb, "Artists' Sessions at Studio 35," in *Modern Artists in America,* Reinhardt and Motherwell (eds.), op. cit., p. 18.

42. Thomas B. Hess, "Is Abstraction Un-American?," *Art News,* vol. 45, no. 10 (Feb., 1951), p. 40.

Chapter 8

1. Harold Rosenberg, "The American Action Painters," *Art News,* vol. 51, no. 8 (Dec., 1952), p. 22-23.

2. Clement Greenberg, "American-Type Painting," *Partisan Review,* vol. 22, no. 2 (Spring, 1955), pp. 179-96.

3. Rosenberg, op. cit., p. 22.

4. Ibid.

5. Ibid.

6. Ibid., p. 23.

7. Ibid., p. 48.

8. Ibid., p. 23.

9. Willard Quine, *Ontological Relativity and Other Essays* (New York: Columbia Univ. Press, 1969), pp. 26-27.

10. Rosenberg, op. cit., p. 23.

11. Ibid.

12. Ibid.

13. Ibid.

14. Robert Motherwell and Harold Rosenberg, "Statement," *Possibilities I* (Winter, 1947-48), p. 1.

15. Rosenberg, op. cit., p. 23, 48.

16. Clement Greenberg, "Towards a Newer Laocoon," *Partisan Review,* vol. 7, no. 4 (July-Aug., 1940), pp. 296-310.

17. Greenberg, "American-Type Painting," p. 179.

18. Ibid., p. 180.

19. Ibid.

20. Ibid., p. 181-82.

21. Ibid., pp. 182, 183.

22. Ibid., pp. 184-85.

23. Ibid., p. 186.

24. Ibid., p. 189.

25. Ibid.

26. Ibid., p. 189.

Chapter 9

1. B.H. Friedman, "The New Baroque," *Arts,* vol. 28, no. 20 (Sept. 15, 1954), p. 12.

2. Aldous Huxley, "Death and the Baroque," cited in B.H. Friedman, "The New Baroque," op. cit., p. 13.

3. Friedman, op. cit., p. 13.

4. Ibid.

5. Ibid.

6. Ibid., p. 12.

7. Ibid., p. 13.

8. Robert Rosenblum, "The Abstract Sublime," *Art News*, vol. 59, no. 10 (Feb., 1961), p. 56.

9. Ibid., pp. 56, 58.

10. Ibid., p. 40.

11. Ibid.

12. Ibid.

13. John McCoubrey, "The New Image," in *American Tradition in Painting* (New York: George Braziller, 1963), p. 115.

14. Ibid., p. 116.

15. Ibid., p. 115.

16. William Seitz, "Space, Time, and Abstract Expressionism," *Magazine of Art*, vol. 46, no. 2 (Feb., 1952), p. 84.

17. Ibid.

18. William Seitz, *Abstract Expressionist Painting in America*. Unpublished dissertation, Princeton, 1955, p. 6.

19. Ibid., p. 5.

20. Ibid., p. 8.

21. Ibid., p. 187.

22. Robert Goldwater, "Reflections on the New York School," *Quadrum*, no. 8 (1960), p. 18.

23. Ibid., p. 20.

24. Ibid., p. 22.

25. Ibid., p. 27.

26. Ibid., p. 30.

27. Meyer Schapiro, "The Liberating Quality of Avant-garde Art," *Art News*, vol. 56, no. 4 (Summer, 1956), p. 42.

28. Leon Golub, "A Critique of Abstract Expressionism," *College Art Journal*, vol. 14, no. 2 (Winter, 1955), pp. 143-44.

29. Rudolf Arnheim, "The Artist Conscious and Subconscious," *Art News,* vol. 56, no. 4 (Summer, 1956), p. 33.

30. Hilton Kramer, "The New American Painting," *Partisan Review,* vol. 20, no. 4 (July-Aug., 1953), p. 421.

31. Ibid.

32. Ibid., p. 423.

33. Ibid.

34. Hilton Kramer, "The Critics of American Painting," *Arts,* vol. 34, no. 1 (Oct., 1959), p. 26.

35. Ibid.

36. Ibid., p. 30.

37. Geoffrey Wagner, "The New American Painting," *Antioch Review,* vol. 14, no. 1 (March, 1954), p. 4.

38. Ibid., p. 13.

Chapter 10

1. Nicolas Calas, "Surrealist Perspective," *Art in the Age of Risk* (New York: E.P. Dutton, 1968), p. 145.

2. Ibid.

3. Monroe Beardsley, *Aesthetics* (New York: Macmillan, 1966), p. 385.

4. Philip Pavia, "Polemic," *It Is,* no. 1 (Spring, 1958), p. 2.

5. Ibid., p. 6.

6. Ray Parker, "Direct Painting," *It Is,* no. 1 (Spring, 1958), p. 20.

7. Piet Mondrian, "4 Excerpts," *It Is,* no. 2 (Autumn, 1958), pp. 32-35.

8. Hubert Crehan, "On Abstract Art," *It Is,* no. 1, (Spring, 1958), pp. 60-63.

9. Philip Pavia, "Manifesto-in-Progress," *It Is,* no. 2 (Autumn, 1958), p. 6.

10. Philip Pavia, "Manifesto-in-Progress," *It Is,* no. 3 (Winter-Spring, 1959), p. 4.

11. Ibid., p. 7.

12. Philip Pavia, "Manifesto-in-Progress," *It Is,* no. 4 (Autumn, 1959), p. 5.

13. Mary McCarthy, quoted in "Critic Within the Act," by Harold Rosenberg, *Art News,* vol. 59, no. 6 (Oct., 1960), p. 26.

14. Harold Rosenberg, "Critic Within the Act," *Art News,* vol. 59, no. 9 (Octo., 1960), pp. 26-27.

15. Ibid., p. 27.

16. Ibid., pp. 27-28.

17. Harold Rosenberg, *The Anxious Object* (New York: New American Library, 1966), p. 19.

18. Ibid., p. 21.

19. Ibid., p. 22.

20. Clement Greenberg, "Post Painterly Abstraction," *Art International,* vol. 8, nos. 5-6 (Sept., 1964), p. 63.

21. Ibid.

22. Clement Greenberg, "Art," *The Nation* (Nov. 29, 1950), p. 491.

23. Clement Greenberg, "Post Painterly Abstraction," p. 63.

24. Ibid.

25. Max Kozloff, "An Interview with Robert Motherwell," *Artforum,* vol. 4, no. 4 (Sept., 1965), p. 37.

26. Maurice Tuchman, *New York School: The First Generation* (Los Angeles: Los Angeles County Museum, 1965).

27. Barnett Newman, "The New York School Question," *Art News,* vol. 64, no. 5 (Sept., 1965), pp. 38-42.

28. Henry Geldzahler, *New York Painting and Sculpture: 1940-1970* (New York: E.P. Dutton, 1969).

29. William Rubin, "Notes on Masson and Pollock," *Arts,* vol. 34, no. 2 (Nov., 1959), p. 36.

30. Ibid.

31. William Rubin, "Arshile Gorky, Surrealism, and The New American Painting," *Art International,* vol. 7, no. 2 (Feb., 1963), p. 27.

32. Ibid., p. 31.

33. Maurice Tuchman (ed.), *New York School,* op. cit., p. 11.

34. Irving Sandler, "The Club," *Artforum,* vol. 4, no. 1 (Sept., 1965), p. 27.

35. Ibid.

36. Irving Sandler, "The Surrealist Emigres in New York," *Artforum,* vol. 6, no. 9 (May, 1968).

37. Irving Sandler, *The Triumph of American Painting* (New York: Praeger, 1970).

38. Irving Sandler, "The Club," p. 30.

39. Ibid.

40. Barbara Rose, "The Politics of Art, Part I," *Artforum,* vol. 6, no. 6 (Feb. 1968), p. 31.

41. Ibid.

42. Ibid., p. 32.

43. Sonya Rudikoff, "Language and Actuality," *Arts,* vol. 34, no. 6 (March, 1960), p. 23.

44. Ibid., p. 24.

45. Ibid., p. 25.

46. Irving Sandler, "An Exchange on Art Criticism," *Arts,* vol. 34, no. 8 (May, 1960), p. 28.

47. Ibid., p. 29.

48. Sonya Rudikoff, "Miss Rudikoff Replies," *Arts,* vol. 34, no. 8 (May, 1960), p. 29.

49. Ibid.

50. Amy Goldin, "Harold Rosenberg's Magic Circle," *Arts Magazine,* vol. 40, no. 1 (Nov., 1965), p. 38.

51. Ibid., p. 39.

52. Ibid.

Chapter 11

1. Barbara Reise, "Greenberg and the Group: A Retrospective View," *Studio International,* vol. 175, no. 900 (May, 1968), pp. 254-57.

2. Max Kozloff, "The Critical Reception of Abstract Expressionism," *Arts,* vol. 40, no. 2 (Dec., 1965), pp. 27-33.

3. Reise, op. cit., pp. 254-55.

4. Ibid., fn. 6, p. 256.

5. Ibid., p. 255.

6. Ibid.

7. Barbara Reise, "Greenberg and the Group . . .," Part II, vol. 175, no. 901 (June, 1968), p. 314.

8. Ibid.

9. Barbara Reise, "Greenberg and the Group. . .," Part I, vol. 175, no. 900 (May, 1968), p. 255.

10. Kozloff, op. cit., p. 27.

11. Ibid.

12. Ibid., p. 31.

13. Ibid., p. 28.

14. Ibid.

15. Ibid.

16. Ibid.

17. Ibid., pp. 28-29.

18. Ibid., p. 28.

19. Ibid., p. 30.

20. Ibid.

21. Ibid., p. 32.

22. Ibid.

Bibliography

Agee, William: New York Dada, 1910-30, in *Avant-garde Art* ed. by Thomas B. Hess and John Ashberry. New York: Collier, 1968.

Alloway, Lawrence: Anthropology and Art Criticism, *Arts,* 45:4, 1971.

Apollinaire, Guillaume: *Les Peintres Cubistes.* Paris: Figuiere, 1913.

_____: Les Independants, Cercle d'Art, 8me Salon, June 10-July 3, 1911.

Arnason, H.H.: *Abstract Expressionists and Imagists.* New York: The Solomon R. Guggenheim Museum, 1961.

Arnheim, Rudolf: The Artist Conscious and Subconscious, *Art News,* 56:4, 1956.

Ashton, Dore: *A Reading of Modern Art.* Cleveland: Press of Case Western Reserve University, 1969.

_____: *The Unknown Shore.* Boston: Little, Brown and Co., 1962.

_____: *The New York School: A Cultural Reckoning.* New York: Viking, 1973.

Aune, Bruce: *Knowledge, Mind and Nature.* New York: Random House, 1967.

Barr, Alfred: *Fantastic Art, Dada, Surrealism.* New York: The Museum of Modern Art, 1936.

_____: A Symposium: The State of American Art, *Magazine of Art,* 42:3, 1949.

Barzun, Jacques: *Classic, Romantic and Modern.* New York: Anchor Books, 1961.

Battcock, Gregory: *Introduction to Art in the Age of Risk* by Nicolas Calas. New York: Dutton, 1968.

Baudelaire, Charles: *The Mirror of Art.* New York: Doubleday, 1956.

Bell, Clive: Art in the Planned State, *Forum and Century,* 47:5, 1937.

Blesh, Rudi: *Modern Art. U.S.A.* New York: Alfred A. Knopf, 1956.

Boswell, Peyton: Comments. *Art Digest,* 14:4, 1940.

Breton, Andre: The Eye Spring of Arshile Gorky, forward to an exhibition catalog. Reprinted in *It Is,* 4, 1959.

Brown, Milton: *American Painting from the Armory Show to the Depression.* Princeton: Princeton University Press, 1970.

Cahill, Holger: *New Horizons in American Art.* New York: The Museum of Modern Art, 1936.

Calas, Nicolas: *Art in the Age of Risk.* New York: E.P. Dutton and Co., 1968.

Carmean, E.A. and Rathbone, Eliza with Hess, Thomas B.: *American Art at Mid-Century: The Subjects of the Artists:* Washington: National Gallery of Art, 1978.

Cendrars, Blaise: Pourquoi le 'Cube' s'effrite, *La Rose Rouge,* 3, 1919.

Coates, Robert: Assorted Moderns, *New Yorker,* 20:45, 1944.

Contemporary American Painting and Sculpture. Urbana: University of Illinois Press, 1948. Subsequent editions printed in 1951 and 1955.

Craven, Thomas: Nationalism in Art, *Forum and Century,* 45:6, 1936.

Crawford, Ralston: Is the French Avant-garde Over-rated?, *Art Digest,* 27:20, 1953.

Crehan, Hubert: On Abstract Art, *It Is,* 1, 1958.

Davenport, Russell: A *Life* Roundtable on Modern Art, *Life,* 25:15, 1948.

De Kooning, Willem: What Abstract Art Means to Me, *The Museum of Modern Art Bulletin,* 18:3, 1951.

Document, *Art Digest,* 28:4, 1953.

Eddy, A.J.: *Cubists and Post-Impressionism.* Chicago: A.C. McClurg and Co., 1914.

Egbert, *Socialism and American Art.* Princeton: Princeton University Press, 1967.

Foster, Stephen: Greenberg: Formalism in the '40s and '50s, *Art Journal,* 35:1, 1975.

_____: The Avant-garde and the Privacy of Mind, *Art International,* 19:9, 1975.

_____: Making a Movement Modern: The Role of the Avant-garde Critic, *Art International,* 20:8-9, 1976.

Frankfurter, Alfred: Blind Justice, *Art News,* 49:4, 1950.

Fried, Michael: Marxism and Critcism, *Arts Magazine,* 36:4, 1962.

Friedman, B.H.: The New Baroque, *Arts,* 20:20, 1954.

_____: *The School of New York: Some Younger Artists.* New York: Grove Press, 1959.

Fry, Edward: *Cubism.* New York: McGraw-Hill, 1966.

Geldzahler, Henry: *New York Painting and Sculpture: 1940-1970;* New York: Dutton, 1969.

Goldin, Amy: Harold Rosenberg's Magic Circle, *Arts Magazine,* 40:1, 1965.

Golding, John: *Cubism.* Boston Book and Art Shop, 1968.

Goldwater, Robert: Everyone Knew What Everyone Else Meant, *It Is,* 5, 1959.

_____: Reflections on the New York School, *Quadrum,* 8, 1960.

_____: Varieties of Critical Experience, *Artforum,* 6:1, 1967.

Golub, Leon: A Critique of Abstract Expressionism, *College Art Journal,* 14:2, 1955.

Gottlieb, Adolf: Artists' Sessions at Studio 35, in *Modern Artists in America* ed. by Reinhardt and Motherwell. New York: Wittenborn, Schultz, 1951.

_____: The Ides of Art, *The Tiger's Eye,* 2, 1947.

Greenberg, Clement: American-Type Painting, *Partisan Review,* 22:2, 1955.

_____: Art, *The Nation,* 160:12, 1945.

_____: Art, *The Nation,* 162:18, 1946.

_____:Art, *The Nation,* 163:2, 1946.

_____: Art, *The Nation,* 167: 24, 1948.

_____: Art, *The Nation,* 168:24, 1949.

_____: *Art and Culture.* Boston: Beacon Press, 1968.

_____: The European View of American Art, *The Nation,* Nov. 25, 1950.

_____: Is the French Avant-garde Over-rated?, *Art Digest,* 27:20, 1953.

_____: New York Painting Only Yesterday, *Art News,* 56:4, 1956.

_____: Post Painterly Abstraction, *Art International,* 8:5-6, 1964.

_____ : The Present Prospects of American Painting and Sculpture, *Horizon* (London), 16:93-94, 1947.

_____: The Renaissance of the Little Mag, *Partisan Review,* 8:1, 1941.

_____: The Situation at the Moment, *Partisan Review,* 15:1, 1948.

_____: A Symposium: The State of American Art, *Magazine of Art,* 42:3, 1949.

_____: Ten Propositions on the War, *Partisan Review,* 8:4, 1941.

_____: Towards a Newer Laocoon, *Partisan Review,* 7:4, 1940.

_____: T.S. Eliot: A Book Review, in *Art and Culture.* Boston: Beacon Press, 1965.

_____: Under Forty, *Contemporary Jewish Record,* 7:1, 1944.

Heidegger, Martin: The Origin of the Work of Art, in *Philosophies of Art and Beauty,* ed. by Hofstadter and Kuhn. New York: Modern Library, 1964.

Heron, Patrick: The Americans at the Tate Gallery, *Arts,* 30:6, 1956.

Hess, Thomas B.: *Abstract Painting: Background and American Phase.* New York: Viking Press, 1951.

_____: Is Abstract Un-American?, *Art News,* 45:10, 1951.

_____: The New York Salon, *Art News,* 52:10, 1954.

Hobbs, Robert and Levin, Gail: *Abstract Expressionism: The Formative Years:* New York: The Whitney Museum of American Art, 1978.

Hofmann, Hans: *Search for the Real.* Cambridge: M.I.T. Press, 1967.

Huelsenbeck, Richard: En Avant Dada, *Possibilities,* 1, 1947/48.

Huxley, Aldous: Death and the Baroque, cited in Friedman, The New Baroque, *Arts,* 28:20, 1954.

James, Henry: Criticism, reprinted in *The Tiger's Eye,* 1:1, 1947.

Janis, Sidney: *Abstract and Surrealist Art in America.* New York: Renal and Hitchcock, 1944.

_____: Introduction to *Mark Rothko.* New York: Art of This Century Gallery, 1945.

Kandinsky, Wassily: *Concerning the Spiritual in Art.* New York: George Wittenborn, 1966.

Kahnweiler, Daniel-Henry: Mallarmé and Painting, in *From Baudelaire to Surrealism* by Marcel Raymond. New York: Wittenbron, 1949.

Kootz, Samuel: Letter to the *New York Times,* printed in E.A. Jewell, The Problem of Seeing, *New York Times,* Aug. 10, 1941, sec. 9, p. 7.

Kootz Kaleidoscopes, *Newsweek,* July 30, 1945.

_____: *New Frontiers in American Painting.* New York: Hastings House, 1943.

Kozloff, Max: The Critical Reception of Abstract Expressionism, *Arts,* 40:2, 1965.

_____: An Interview with Robert Motherwell, *Artforum,* 4:1, 1965.

Kramer, Hilton: The Critics of American Painting, *Arts,* 34:1, 1959.

_____: The New American Painting, *Partisan Review,* 20:4, 1953.

Kuhn, Thomas: *The Structure of Scientific Revolutions,* Chicago: University of Chicago Press, 1970.

Lansford, Jules: Baziotes in Solo Show, *Art Digest,* 22:10, 1948.

MacAgy, Douglas: A Symposium: The State of American Art, *Magazine of Art,* 42:3, 1949.

_____: Western Roundtable on Modern Art, version in *Modern Artists in America* ed. by Reinhardt and Motherwell. New York: Wittenborn, Schultz, 1951.

McCoubrey, John: *American Tradition in Painting.* New York: George Braziller, 1963.

Malraux, André: The Work of Art, *Partisan Review,* 2:9, 1935.

Margolis, Joseph: The Logic of Interpretation, in *Philosophy Looks at the Arts* ed. by Margolis. New York: Charles Scribner's Sons, 1962.

Miller, Dorothy: *Fourteen Americans.* New York: The Museum of Modern Art, 1946.

_____: *Fifteen Americans.* New York: The Museum of Modern Art, 1952.

Mondrian, Piet: Four Excerpts, *It Is,* 2, 1958.

Motherwell, Robert: Is the French Avant-Garde Over-rated?" *Art Digest,* 27:20, 1953.

_____, and Reinhardt, A.: *Modern Artists in America.* New York: Wittenborn, Schultz, 1951.

_____: The Modern Painters' World, *Dyn,* 6, 1944.

_____: Prefatory Notice, in *From Baudelaire to Surrealism* by Marcel Raymond. New York: Wittenborn, 1949.

_____, and Rosenberg, Harold: Statement, *Possibilities,* 1, 1947/48.

Newman, Barnett: The First Man Was An Artist, *The Tiger's Eye,* 1, 1947.

_____: The New York School Question, *Art News,* 64:5, 1965.

Oliver-Hourcade: *Paris Journal,* Oct. 23, 1912.

Paalen, Wolfgang: Introduction (Amerindian Issue), *Dyn,* 4-5, 1944.

Parker, Ray: Direct Painting, *It Is,* 1, 1958.

Pater, Walter: *The Renaissance.* New York: The New American Library, 1959.

Pavia, Philip: Advice to Future Polemicists, *It Is,* 5, 1960.

_____: Manifesto-in-Progress, *It Is*, 2, 1958; 3, 1959; 4, 1959.

_____: Polemic, *It Is*, 1, 1958.

Phillips, Duncan: Personality in Art: 1 & 2, *Magazine of Art*, 28:2, 1935; 28:3, 1935.

Poggioli, Renato: *The Theory of the Avant-garde*, New York: Harper and Row, 1971.

Pollock, Jackson: My Painting . . ., *Possibilities*, 1, 1947-48.

"Pollock," *Art News*, 45:3, 1946.

Putzel, Howard: A Problem for the Critics, *New York Times*, July 1, 1945, sec. 2, p. 2.

Quine, Willard: *From a Logical Point of View*. New York: Harper and Row, 1963.

_____ : *Ontological Relativity and Other Essays*. New York: Columbia University Press, 1969.

Rahv, Philip: The Cult of Experience in American Writing, *Partisan Review*, 7:6, 1940.

Raymond, Marcel: *From Baudelaire to Surrealism*. New York: Wittenborn, 1949.

Reise, Barbara: Greenberg and the Group: A Retrospective View, *Studio International*, 175: 900, 1968.

Riley, Maude: Jackson Pollock, *Art Digest*, 19:13, 1945.

Ritchie, Andrew C.: *Abstract Painting and Sculpture in America*. New York: The Museum of Modern Art, 1951.

Rose, Barbara: The Politics of Art, Part I, *Artforum*, 6:6, 1968.

Rosenberg, Harold: The American Action Painters, *Art News*, 51:8, 1952.

_____: *The Anxious Object*. New York: New American Library, 1966.

_____: *Arshile Gorky*. New York: Horizon Press, 1962.

_____: The Art World: The Profession of Art, *New Yorker*, 48:15, 1972.

_____ : Collective, Ideological, Combative, in *Avant-garde Art* ed. by Thomas B. Hess and John Ashberry. New York: Collier, 1968.

_____: Critic Within the Act, *Art News*, 59:6, 1960.

_____: *The De-definition of Art*. New York: Horizon Press, 1972.

_____: The Fall of Paris, in *The Tradition of the New*. New York: McGraw-Hill, 1960.

_____: The Front, *Partisan Review*, 2:6, 1935.

_____: Introduction to Six American Artists, *Possibilities*, 1, 1947-48.

_____ : Introduction to *From Baudelaire to Surrealism* by Marcel Raymond. New York: Wittenborn, 1949.

_____: The Jewish Writer and the English Tradition, *Commentary*, 8, 1949.

_____ : Parable of American Painting, in *Tradition of The New*. New York: McGraw-Hill, 1965.

_____: Pathos of the Proletariat, *Kenyon Review*, 11:4, 1949.

_____: The Resurrected Romans, *Kenyon Review*, 10:4, 1948.

_____, and Motherwell, Robert: Statement, *Possibilities*, 1, 1947-48.

_____: The Teaching of Hans Hofmann, *Arts Magazine*, 45:3, 1971.

_____: *The Tradition of the New*. New York: McGraw-Hill, 1960.

Rosenberg, Léonce: Tradition and Cubism (1919), in *Cubism* by Edward Fry. New York: McGraw-Hill, 1966.

Rosenblum, Robert: The Abstract Sublime, *Art News*, 59:10, 1961.

Rothko, Mark: The Romantics Were Prompted, *Possibilities*, 1, 1947-48.

Rubin, William: Arshile Gorky, Surrealism, and the New American Painting, *Art International*, 7:2, 1963.

_____: Notes on Masson and Pollock, *Arts*, 34:2, 1959.

Rudikoff, Sonya: Language and Actuality, *Arts*, 34:6, 1960.

Saisselin, R.G.: *Taste in Eighteenth Century France*, Syracuse: Syracuse University Press, 1965.

Sandler, Irving: The Club, *Artforum*, 4:1, 1965.

_____: The Surrealist Emigres in New York, *Artforum,* 6:9, 1968.

_____: *The Triumph of American Painting.* New York: Praeger, 1970.

Schapiro, Meyer: The Liberating Quality of Avant-garde Art, *Art News,* 56:4, 1956.

_____: Nature of Abstract Art, *Marxist Quarterly,* 1:1, 1937.

_____: The Social Basis of Art, in *First American Artists' Congress.* New York, 1936.

Seitz, William: *Abstract Expressionist Painting in America.* Unpublished Ph.D. Dissertation, Princeton University, 1955.

_____: Space, Time, and Abstract Expressionism, *Magazine of Art,* 46:2, 1953.

Soby, James Thrall: *Contemporary Painters.* New York: The Museum of Modern Art, 1948.

Stephan, Ruth: Editorial, *The Tiger's Eye,* 1, 1947:3, 1948; 7, 1949.

Sutton, Denys: The Challenge of American Art, *Horizon* (London), 20:118, 1949.

Sylvester, David: Mr. Sylvester Replies, *The Nation,* Nov. 25, 1950.

Sypher, Wylie: *Rococo to Cubism in Art and Literature.* New York: Vintage, 1960.

Tuchman, Maurice: *New York School—The First Generation.* Los Angeles: Los Angeles County Museum, 1965.

Venturi, Lionello: *History of Art Criticism.* New York: Dutton, 1964.

Wagner, Geoffrey: The New American Painting, *Antioch Review,* 14:1, 1954.

Welleck, René: *Concepts of Criticism.* New Haven: Yale University Press, 1967.

Whorf, Benjamin L.: *Language, Thought and Reality.* Cambridge: M.I.T. Press, 1969.

Williams, William Carlos: The American Background, in *America and Alfred Stieglitz.* New York: Doubleday, Doran and Co., 1934.

Wright, W.H.: *Modern Painting: Its Tendency and Meaning.* London: J. Lane, 1915.

Index